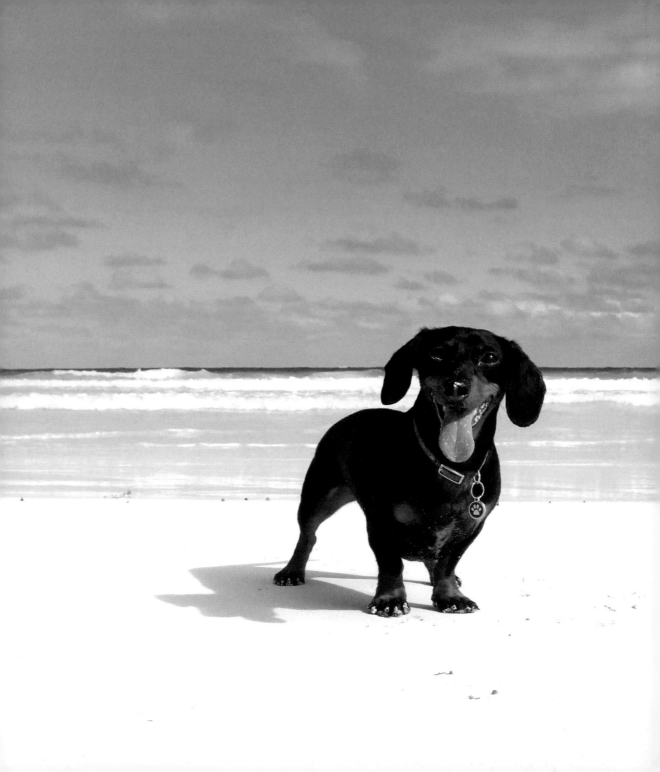

CRUSOE

THE CELEBRITY DACHSHUND

ADVENTURES OF THE WIENER DOG EXTRAORDINAIRE

RYAN BEAUCHESNE

ST. MARTIN'S GRIFFIN ❧ NEW YORK

www.stmartins.com

The Library of Congress Cataloging-in-Publication Data is available upon request.

ISBN 978-1-250-07439-3 (hardcover)
ISBN 978-1-4668-8602-5 (e-book)

St. Martin's Griffin books may be purchased for educational, business, or promotional use. For
information on bulk purchases, please contact the Macmillan Corporate and Premium Sales
Department at 1-800-221-7945, extension 5442, or write to specialmarkets@macmillan.com.

First Edition: October 2015

10 9 8 7 6 5

This book is dedicated to
my best friend, Laffie.

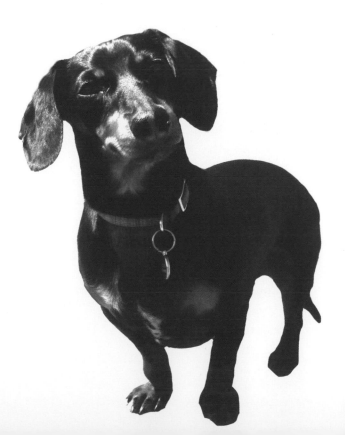

Contents

SUMMER

FALL

WINTER

SPRING

Introduction

My name is Crusoe the Celebrity Dachshund. I am a miniature black and tan dachshund. But don't take "miniature" too literally. I was named after Robinson Crusoe for my deep sense of adventure and my natural ability to instill fascination in my adoring fandom.

A few years ago I started a blog. Since then my life has changed dramatically as I grew into a world-famous celebrity dog.

It was the early, iconic photo of me on the next page that soon evolved to become my logo, now recognized by most likely billions of people across the globe.

Anyway, I'm a small dog but a BIG deal. Alongside my celebrity status, I also have

an impressive résumé with such prestigious titles as BATDOG, captain, chef, doctor, expedition leader, pilot, intrepid adventurer, accountant of the highest designation, world traveler, womanizer extraordinaire, and many more.

Although I do enjoy the pampered celebrity lifestyle and the flashing lights of the big city, I am in fact a country dog born and raised. It was from this upbringing that I gained my sense of adventure, my impeccable physique and savvy for the great outdoors. I have many impressive squirrel-tail trophies mounted on my wall, as well as many books about my adventures lining the shelves of my mahogany bookcase, and I have personally been responsible for many a partridge dinner.

I even have my own executive chair where I often sit to ponder the mysteries of the universe, think up my next killer pickup line, or, occasionally, enjoy a good squeak (see page 3, left).

You would call most animals "cute" or "cuddly," but I am most commonly described as handsome, sexy, chiseled, charming, chivalrous, and a "hunk-o'-burnin' love." In fact, I've even

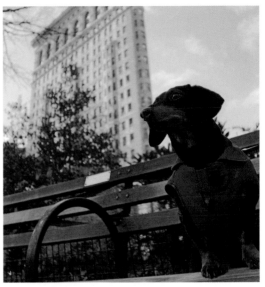

had people tell me that if they were a dog, they'd date me.

Which is pretty understandable.

So anyway, my celebrity life began when I was only a year old. I won a local wiener dog race, got featured on the local news, saw my face on TV the same night—really really enjoyed seeing my face on TV—and thus decided I wanted to become a celebrity.

A few years later, here I am in New York City just outside the iconic Flatiron Building to meet the team at St. Martin's Press and to sign my book deal.

If my ego hadn't already gone to my head, it sure has now.

I knew this was just the beginning, though—the tipping point to many more opportunities and grand adventures to come.

I've organized my book by the sea-

sons, since they're so prominent where I'm from, and because I enjoy them all. So get ready!

 Keep signin',
Crusoe

SUMMER

In the Beginning: Puppyhood

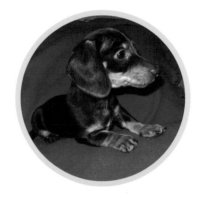

My celebrity career didn't officially begin until I was about a year old, so my puppy years were unspoiled by photo shoots, flashing lights, and paparazzi. This was before Mum and Dad took on the role as my PR and marketing managers, and before virtually every minute of my life became documented for millions to see.

I was born in Montreal, Canada. It was a confusing time. My brothers and sisters had all disappeared, leaving me as the last puppy of the litter.

I was shy and timid, but when my new Mum came to see me, I immediately related to her soft and calm personality, and I went right over to greet her and let her pet me. I guess it was love at first sight, and you know what they say: The last puppy is oftentimes the most appreciative of its owners.

So, Mum and Dad took me to my new home near Mont Tremblant, Quebec.

This is the first photo ever taken of me by Mum and Dad, at my new home on the very first day.

However, it didn't take many photos for Dad to notice that I was going to be a hit with the ladies. . . .

I'm a natural-born ~~wiener~~ winker ;)

He also later discovered after taking his first selfie with me, that I am very photogenic. . . .

. . . Much more so than he is! So, from that point forward, Dad stopped taking selfies—and started only taking photos of me.

Mum and Dad weren't the only ones present throughout my puppyhood, though. There was also another dog, Laffie, who's been my mother figure and role model to this day.

She's a French Brittany Spaniel, and was already about ten years old when I met her as a pup. Her whole life has been lived as a country dog, and with no restraints. She's the type of dog you just open the door for and she goes off, to come back when she pleases. No fences, no gates, no leashes—nothing.

It wasn't long before I followed the same routine, learning from her training and example. It was from her that I learned everything I know today about hunting, tracking, chasing, and leading expeditions through the untamed wilderness.

From kayaking trips to marches through deep snow, from organized squirrel ambushes to exploring new frontiers, I kept up with her from the beginning despite being less than a quarter of her size.

So that, folks, is how I developed my muscles.

And it was my muscles and impeccable physique that helped catapult my career as a celebrity. I was about to be the hunkiest, handsomest wiener dog to ever step on the Internet scene.

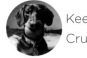

Keep explorin',
Crusoe

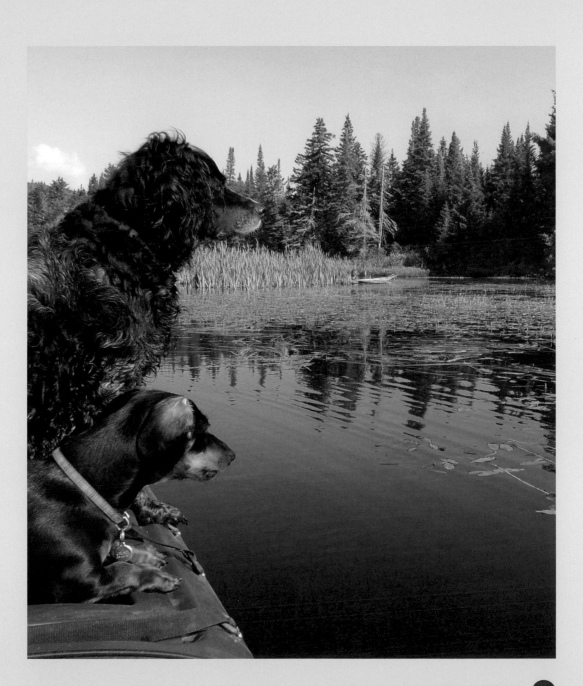

Chef Crusoe

Steak à la Squirrel & Sweet Potatoes

Being a hunter myself, I also take pride in being able to prepare the food I catch. So today I'm going to prepare steak à la squirrel.

Everyone always blabs about how you have to cook with love. Well, I prefer to cook with lust.

INGREDIENTS

A nice big, juicy squirrel steak (You can catch one yourself or just hire me to do so.)

1 sweet potato (You can probably catch this yourself.)

Kinky coconut oil

Rice (for the unadventurous out there)

Step 1: Lick It

The first step here is to lay your squirrel steak out on the cutting board, and give it a good conquering stare to tell yourself you won't take a bite out of it until you're done preparing the meal.

You're also probably wondering how a steak this big could have come from the squirrel I caught last week, but I assure you, it was a big squirrel.

Step 2: Spank It, Baby

Now we have to tenderize this steak so that it melts in our mouth. Us dogs often forget to chew when it comes time to eating something as scrumptious as this, so it's best to at least serve it *somewhat* pre-chewed.

Most people would call this action "tenderizing," but we're making this meal with lust, and so it's called "spanking it."

As you might imagine, I am quite proficient at this technique.

Step 3: Bust Out the Oil

That's right—we're about to get kinky with some coconut oil, which is really good for dogs both as a food and an exterior application. It has anti-inflammatory, antibacterial, and antifungal properties, whatever the heck all that means.

Most important, it's tasty and really good for our health, and makes for a lustrously good time.

This is what we're going to use to sear our steak in.

But as a dog with authorized access to snoop in the cupboard, take this opportunity to make a mental note of any stashes of treats or cookies in there. I will exploit this at a later chance when Mum and Dad are unaware.

Step 4: Intermission

I know it's just getting exciting, but this is where I briefly step out of the kitchen for a quick interlude. You see, supposedly the potatoes take longer to cook than the steak, and due to my limited foresight we now have to play "catch-up" on the potatoes so everything will be ready at the same time.

I told Mum that nobody wants to see me cook potatoes (because they're boring), and I asked her if she could do it while I caught a quick nap.

Step 5: Make It Sizzle

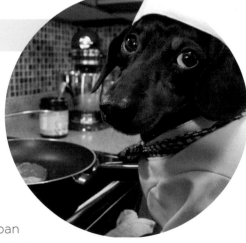

Now for the fun part. This is where we add our coconut oil to the pan, let it melt down (which it will do quickly), and then toss in our steak.

Are you paying attention?

Good.

It's important to hear the sizzle. Shaking the pan back and forth doesn't really do anything, but it does enhance the sound and make you look more like a chef.

Step 6: Indulge the Senses

And finally, now we get to indulge in our delicious creation. With this meal I recommend a nice Pinot Noir or Cabernet Sauvignon, or the lukewarm water from your drinking bowl—but feel free to pair with whatever best suits your taste.

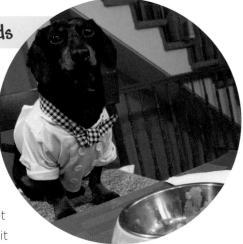

Take a (brief) moment to admire your creation, sniff the aromas, and let the slobber build up in your mouth. (That part's important!)

And when you're ready, chow down like it's your last meal on Earth.

Step 7: Brag About It to Your Friends

So make sure to brag about your delicious meal to friends. You know, on Instagram, Facebook—whatever your usual go-to sharing site is.

And don't worry; no one will blame you if you only eat the good stuff.

Hope you liked my steak à la squirrel and sweet potatoes meal. It was absolutely delicious. Try it yourself sometime!

Keep sizzlin',
Chef Crusoe

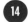

 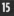

Going to the V.E.T.

I developed my mistrust of vets at a very early age. It all started when I sprained my shoulder while performing a daring seven-foot leap across a stream in pursuit of a particularly voluptuous hare.

Okay, okay—that's just what I tell people. The true story is that Mum pushed me off the bed. Well, sort of. I was sleeping on top of the covers next to Mum, who was fast asleep. Dad had stayed up a bit to watch TV (which Mum is never happy about), but when he climbed into bed, Mum rolled over (deep in sleep) and accidentally sent me over the side.

Bam!

How's that for a "rude awakening"? I was not impressed. Anyway, after Dad checked on me, I went back to sleep in my own bed this time. However, in the morning it became apparent I was limping, and thus, I had to go to the vet.

It was at this point that the vet said, "Ah, I see he's developed a lameness. . . ."

I responded, "Excuse me, you QUACK! I am NOT lame! I am a world-famous Internet celebrity who gets more action than a Hollywood movie set! Look me up!"

That put him in his place, and was the defining moment from which vets would always be considered quacks to me.

Mum insisted I get an X-ray to make sure I was okay. And as I figured, my strong bones and rippling muscles protected me from any damage.

So once I was all cleared, and the vet left the room, I couldn't help but sneak

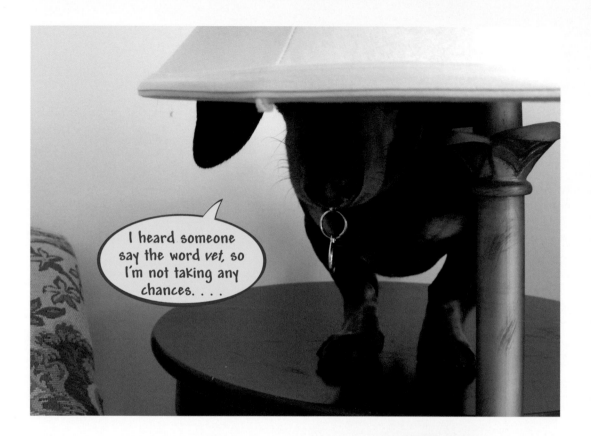

over to his computer to edit my medical record. I replaced the vet's wording of "some lameness seen in the front-right shoulder," to "total awesomeness all over."

(Sorry about the photo quality—this one was taken rather in haste before the vet came back.)

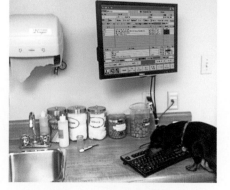

 Keep quackin', Crusoe

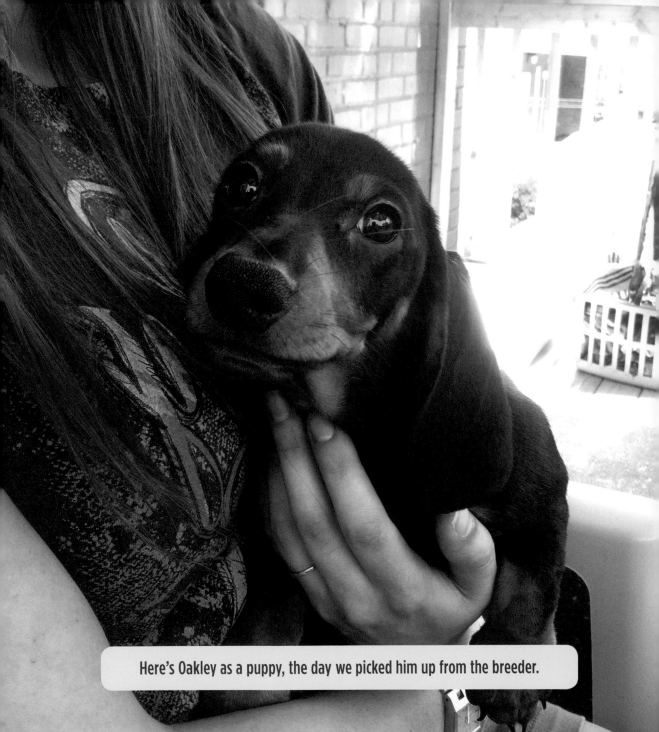

Here's Oakley as a puppy, the day we picked him up from the breeder.

Along Comes My Brother

About a year and a half after my birth, the parents of my Dad added a new furry member to their family—and that little puppy was Oakley.

Oakley came from the same breeder, and even had the same father as me (he got around, evidently).

He looks a lot like me as you may notice! Well, there's one key way to tell us apart. I have a distinctive anchor-shaped birthmark on my nose. In fact, it's become my own trademark.

Here's a quick comparison:

I'm on the left. You can tell because of my anchor nose for one thing, but I also have a sexy white patch on my chest, and a taller, leaner physique. On the other hand, Oakley is short and stout, bow-legged, and has longer ears.

Little did Oakley know that he was joining a celebrity family, destined to eventually ride the coattails of my fame to his own celebrity status.

He would also become the perfect complement to my handsome, chiseled, composed, and chivalrous self—as he is

goofy, often confused, clumsy, but all in all, a big cutie.

As we soon learned, Oakley is also quite a mischief maker. Above, he is acting all "innocent" to the fact he was just ripping apart my favorite ducky.

Oakley and I are best buddies, and have many adventures together. Yet, like any younger brother, he can also be bothersome, oftentimes getting all up in my face.

On the next page is Oakley as a puppy being introduced to the lake for the first time!

I think he might have found it a little chilly.

Yet, despite that "warm" introduction to swimming, Oakley learned to love the water! To this day, he enjoys it more than I do, and can swim like an otter.

Oakley isn't with me all the time, though, because he lives with the parents of my Dad, which is a five-hour car ride (forty-five-minute plane ride) from where I live. So we don't actually see each other very often, unfortunately—but when we do, it's always a blast!

 Keep swimmin',
Crusoe

 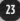

Moving to the City

When I was about two years old, my celebrity career was well under way. And so my family and I decided to move to the big city to pursue more opportunities (also because Dad got a new job there). It was sad to leave my home in the country and move to the noisy, stinky city, but my home in Quebec—now to be considered my

"chalet"—would still be there, and to this day we still return every other weekend for a little getaway back to the wild.

Anyway, I was a bit embarrassed when Mum and Dad came home with a bunch of banana boxes from the grocery store to use as moving boxes. What kind of cheapos am I living with. . . ?

I dubbed myself "moving coordinator" for the day, to avoid doing any of the actual work myself and just focus on what I'm good at—being bossy!

"Mum, I want you to categorize my toys into 'balls,' 'stuffed animals,' 'chew toys,' 'rope toys,' and 'other' and then pack them into separate boxes accordingly."

(You need to be organized to be the moving coordinator.)

So anyway, of course Mum didn't do

it exactly as I wanted, even with my clear directions. If you want something done right, you have to do it yourself, so I just had to get in there and fix things myself.

In retrospect, it wasn't the best idea for me to get involved, because once I started pulling my toys out I couldn't help but want to play with them. In the end, I just ended up unpacking the boxes.

So once Mum and Dad finally got their act together and packed the boxes, I went around for one last inspection.

And it was only while writing this that I noticed I had dried yogurt on my nose the whole time. Heck, as my PR and marketing managers, Mum and Dad should really have let me know. . . .

I was also looking to ensure Dad packed my trophies and awards delicately.

The commotion of moving lasted a good part of the day, and I was getting tired of following Mum and Dad around to supervise them.

So when all the boxes were loaded onto the truck, I went along for the ride. I had to make sure none of my toys "fell off the back of the truck" along the way, if you know what I mean.

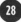

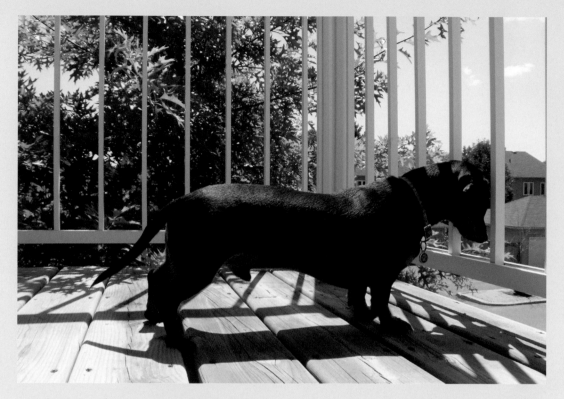

When we finally arrived at our new home, I was very excited! Mum and Dad never took me for a viewing prior to moving in (which is something you should do with your dog, btw), and so that was a somewhat controversial subject within our family at the time.

I smelled something peculiar upon entering the new home. I asked Mum what it was, and she informed me that there used to be a CAT in this house!

So our little "controversial subject" just became a lot bigger. I would address that matter another time, though.

In the meantime, I had a brand-new home to explore. And one of my immediate favorite parts was the sweet balcony!

This will be perfect for midday snoozes in the sun, as well as for babe watching. I'm not sure if the ladies will be able to hear my catcalls (ironically titled, I know) from up here, so I've asked Dad to pick up a couple of standard water-safety whistles for me.

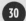

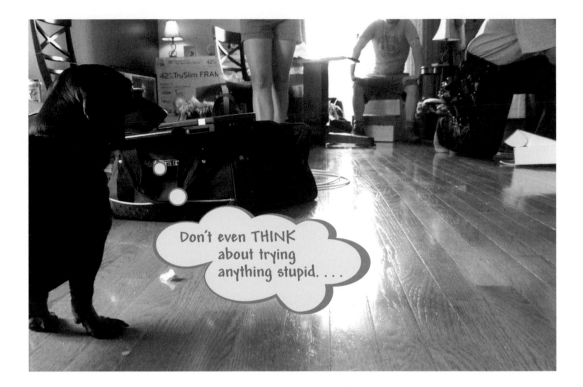

Don't even THINK about trying anything stupid. . . .

I also quickly learned that dropping my ball from the balcony to make Dad go get it is a very fun game!

So after checking out the home and giving it my approval, it was time to unpack.

I found a great little shelf on a side table that I used as my lookout point for supervising the unpacking—although admittedly, it was a bit uncomfortable and awkward.

And once Dad unpacked all my trophies, I gave them a nice dusting and polishing, since after all, they're the centerpieces of our living room now.

The last thing we had to do was to get the cable and Internet installed so that I could start blogging again. However, I have never been a fan of cable guys.

I told Mum not to worry, and that I had my eye on him. . . .

 Keep movin',
Crusoe

The Stowaway Attempt

Up until now in my life, I had never gone on a vaca-tion. As far as I was concerned, this was unacceptable for a celebrity of my stature.

So I demanded Mum bring me with her on her upcoming trip to Saint Lucia. She works in the travel industry and often has to travel for "business purposes" (ya right).

Mum insisted she couldn't bring me on this trip, but that as soon as she was back, we would plan a trip to somewhere I could go.

That still wasn't good enough for me.

My main plan was to hide in her suit-case. So the morning she was leaving, and in cooperation with Dad (he's always on my side), while she was busy getting ready, I slipped silently over to her suit-case and hopped in. I immediately began

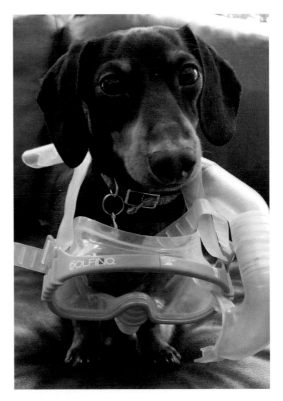

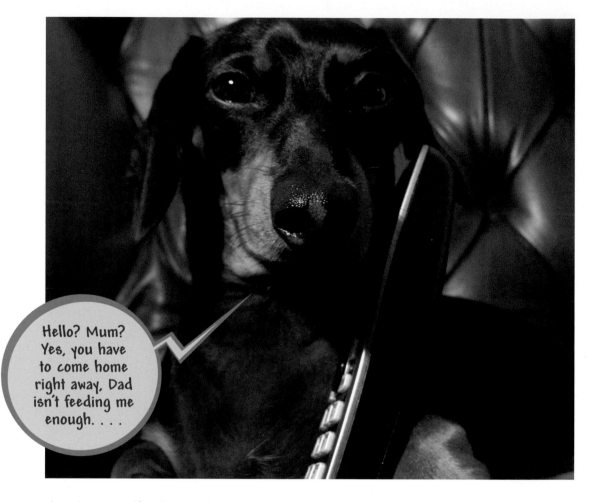

Hello? Mum? Yes, you have to come home right away, Dad isn't feeding me enough. . . .

dressing myself in her undergarments so she wouldn't recognize me. A sock on the nose was the final touch. I thought for sure she wouldn't find me now. . . .

To this day, I still don't know how she found me—perhaps just a mother's instinct? But, dang it, the jig was up!

As a last resort I tried sporting the good ol' puppy eyes. . . .

Nope . . . didn't work. "Oh well, I guess I'll stay with Dad for a week."

 Keep tryin',
Crusoe

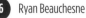

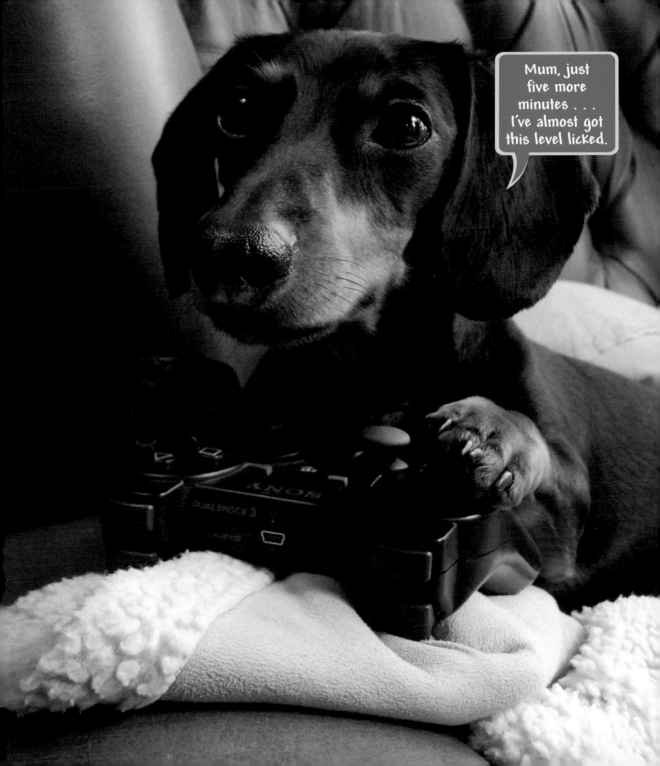

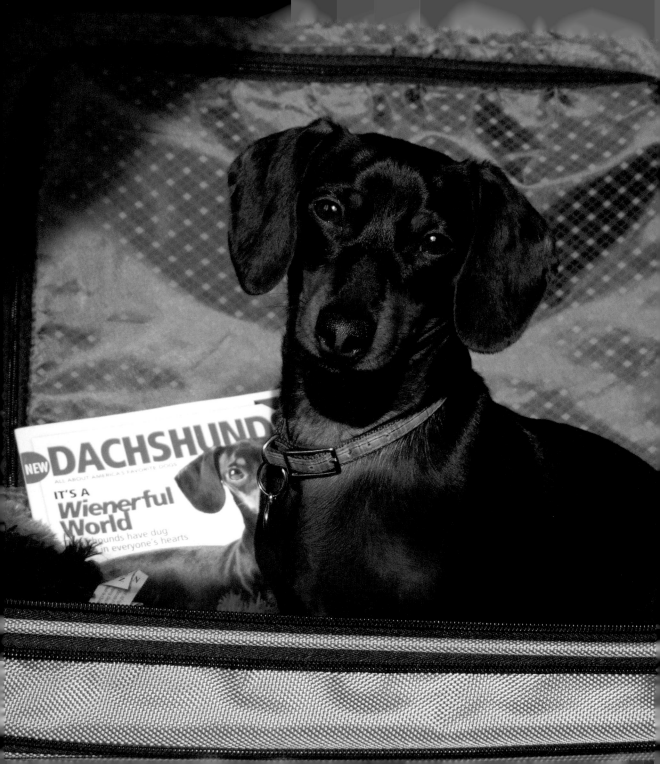

My First-Ever Vacation!

Finally the day had come for me to go on a real vacation. We were going to Florida, where Mum and Dad have a vacation home— which I never knew about until now!!!

What kind of baloney is that? Oh well, I guess they didn't want to spoil me as a puppy with the luxuries of a celebrity until I learned how to handle it all. (But for the record, I still don't know how to handle it all.)

So anyway, I was quite excited to say the least. I had my dachshund magazine and toys all ready to go a week before our departure date!

When the day finally came, I trotted through the airport as if I were the happiest dog on the planet. And just for fun, I made sure I met the carry-on restrictions.

Yet despite my eager excitement, when

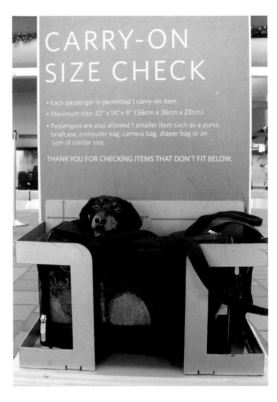

it came time to board the plane I couldn't help but feel a bit uneasy as I looked back at Dad for reassurance.

He gave me a nod and wink to signal that "everything's okay."

What I didn't realize, though, was that I had to be zipped up and tucked under the seat in front for the whole flight . . . !

"Hold it right there," I said as I placed my paw across the zipper. "Are you seriously going to zip me up in this bag and stuff me under the seat like some animal?!

"Dad, as my father and manager, I demand you fight for the injustice that is being inflicted upon me and get me the first-class seat with on-demand snack service and television I so rightfully deserve!"

Partway through the flight Dad was worried I might have to pee (he didn't want me to go in my bag!) so he picked me up and brought me into the airplane bathroom. He laid my pee pad on the floor and tried to get me to go, but I wouldn't.

So Dad tried peeing a little bit himself on the pee pad, thinking that might spur me into going. Well, it didn't, I just thought he was incredibly weird.

Anyway, he gave up, but he never should have doubted me, for I was born to fly. I was incredibly well behaved the whole flight; I didn't make a peep or have

one accident, and from that day forward I've been an excellent traveler.

So after my first flying experience and arriving in the foreign land of Florida, the first thing we did was hit the beach. This was what I'd been waiting for!

And I still remember wading into the surf for the first time in my life!

This beach was called HoneyMoon Beach, and for good reason. While trotting through the soft sand, I came across this sexy beachgoer named Coco (a perfect name for a tropical romance). She wasn't shy around a celebrity, though—

Mum and Dad told me it was a manatee, an animal that's like a slow-moving, gentle, underwater cow.

Sounded made-up to me, so I had to take a closer look for myself.

"Lower the life rafts!" I called. "Mum, steer me to the place you saw this mythical creature!"

However, as much as I looked, I just couldn't see it. For all I knew, it could have been right under my nose. . . .

And guess what, it was! I had been only a few feet away from this giant creature, floating peacefully underneath me.

Regardless, they're a boring type of fish if you ask me. I prefer the ones that wriggle and splash all over the place.

So I decided to practice my swimming instead. Mum still thinks I have a chance of going to the Olympics. . . .

we had barely said "hi" before she was all up in my junk!

So, things progressed from there, but heck, what's a little fling? (We still keep in touch, though.)

Our next outing was to be a full day out on the water!

One of the places we went to was Florida's beautiful Rainbow River—one of the Top Ten clearest rivers in the world.

After a while we stopped the boat and everyone became very quiet. My friend Laffie was fixated on something in the water. . . .

As Mum and Dad noticed, though, when I swim it's only my two front paws that move. My back legs just stay tucked

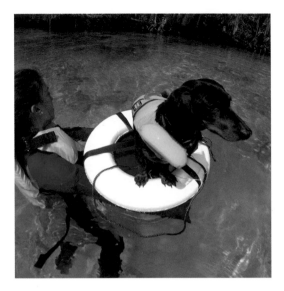

up, twitching occasionally to keep my loglike form from rolling over.

After drying off, it was on to the kayaks!

And I had my eyes peeled for whatever type of new creature I might see—below or above water!

And just when I thought there was nothing more mysterious than this supposed "sea cow," I heard this strange screeching from the treetops!

Monkeys! I couldn't believe it—this was a creature I had heard about before! (Since Mum always calls me her "little monkey.")

As if that wasn't impressive enough, on our way down the river I was flab-

bergasted to see a dragon sitting on the shore!

Dad told me this was a gator, and unlike the manatees, I had to be very wary of them, for they're dangerous.

I laughed at that. Doesn't Dad know by now that I dance in the mouth of danger?

But after all that excitement, I couldn't help feel like a brave explorer of a new land. . . .

All in all, it was a fantastic first vacation, and it gave me a thirst for more!

Keep travelin'
Crusoe,

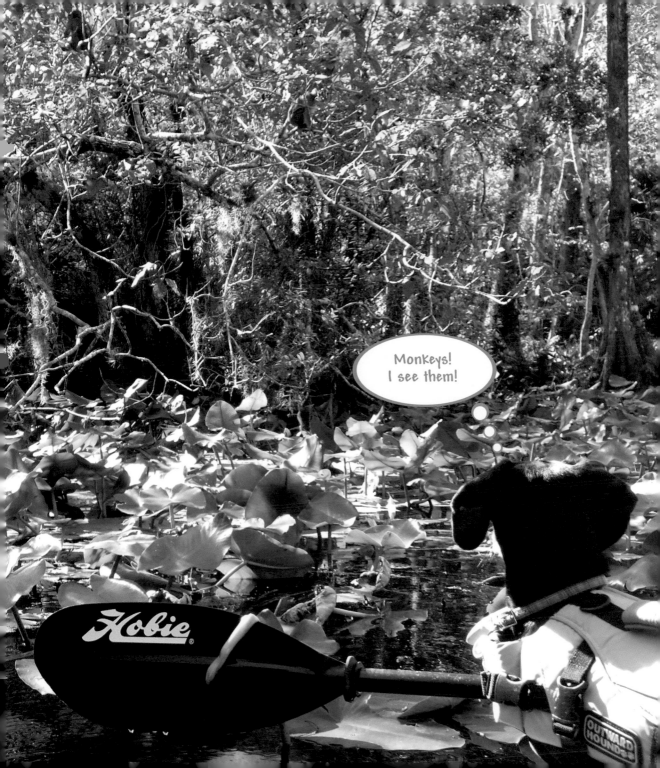

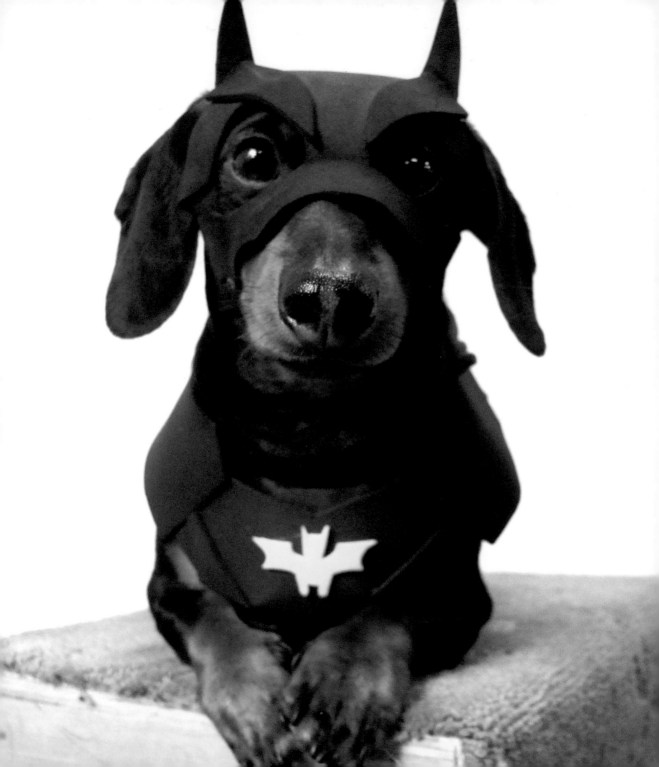

BATDOG: the Beginning

It may come as a surprise that little ol' mild-mannered Crusoe has a pretty impressive alter ego. Well, I have many alter egos in fact, but right now I'm talking about my most notorious, admired, and famed alter ego: BATDOG!

Now you're probably wondering—isn't being a celebrity enough? Let alone taking on the role of a crime-fighting superhero dog? Well, being a celebrity is a lot of work, no doubt, but I figured if a busy businessman like Bruce Wayne can be Batman, then there's no reason a wiener dog can't be BATDOG.

You're also probably wondering why I've exposed my identity and not kept it a secret. Well, contrary to the vast majority of superheroes, I'm in it for the fame and

glory. That and the ladies. We might as well get that straight from the beginning.

So if you're ever in trouble and need to call upon BATDOG with the symbol below, make sure you have a camera ready to snap some pictures of me saving you, otherwise I can't guarantee I'll help you.

Please keep in mind that this is not a costume. BATDOG does not wear a costume—this is a custom-engineered, flame-resistant, and bulletproof *OUTFIT*. . . .

So when being a plain ol' celebrity becomes tiresome, I put on my BATDOG outfit and go looking for criminals—or

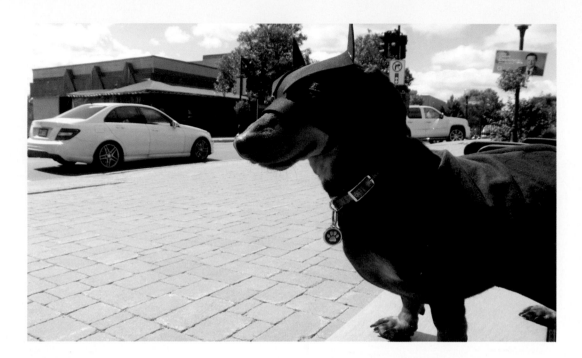

more accurately, sexy ladies in need of saving.

Sometimes I have to wait around a while before Mum can give me a ride into town, though. . . .

Once we're in town, I stand guard on a street corner to watch for any suspicious activity. It's not as if I'm going to give anybody a speeding ticket, but for some reason cars always slow down as they pass by me.

I guess I'm just that intimidating.

And when Mum wants to go visit a store, I make sure to go with her. No one in their rightful mind is going to try to steal her purse with BATDOG at the end of her leash!

It's a bit bothersome to always be relying on Mum to give me a ride into the danger zones, though (doesn't seem very superhero-like); so on the way back I made sure we stopped at a motorcycle dealership to buy myself the BATBIKE.

I asked the dealer if I could get an upgrade for a guided-missile system add-on, but unfortunately they didn't have any available. So I'll have to check what Amazon might have.

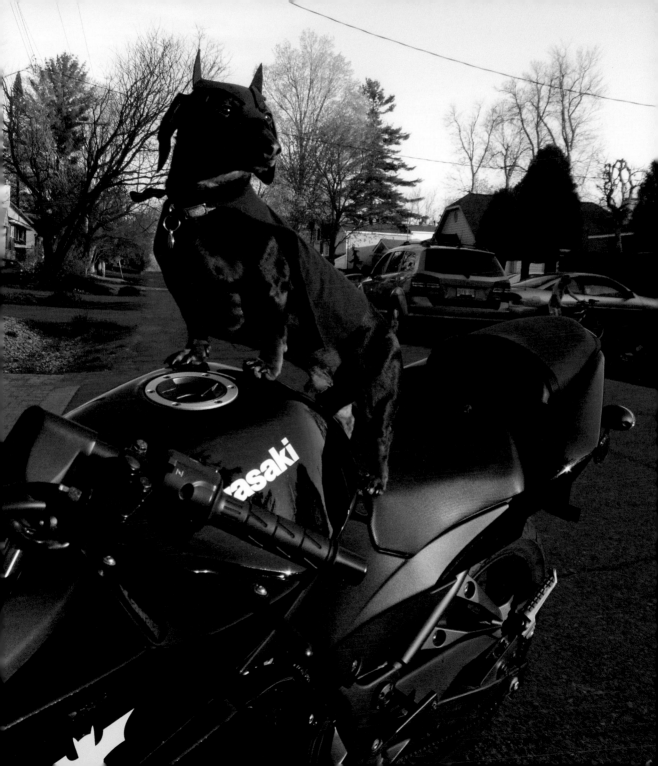

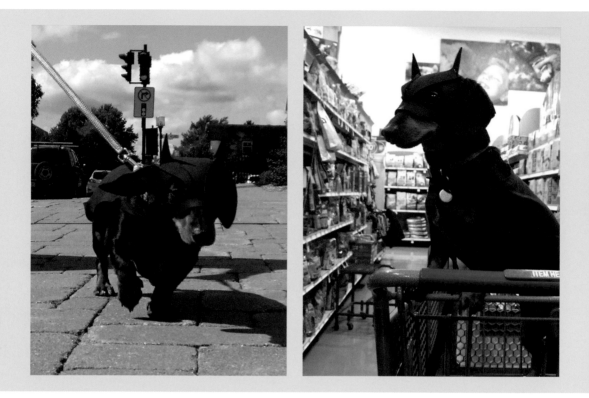

While we were on the subject of shopping, I made Mum take me to the pet store as well.

I was hoping to catch a few shoplifters red-handed—which would be even better if they were cats—but unfortunately my town is too "well behaved."

Blah, boring!

When there's no chicks around in need of saving though, I like to work on my poses. You never know when that emergency call is going to come in, and I need to be prepared to have my photo taken.

I wasn't destined to be the only superhero in the family, though! Soon enough, my brother Oakley would join me as my sidekick—Robin!

 Sexy ladies, keep callin', BATDOG

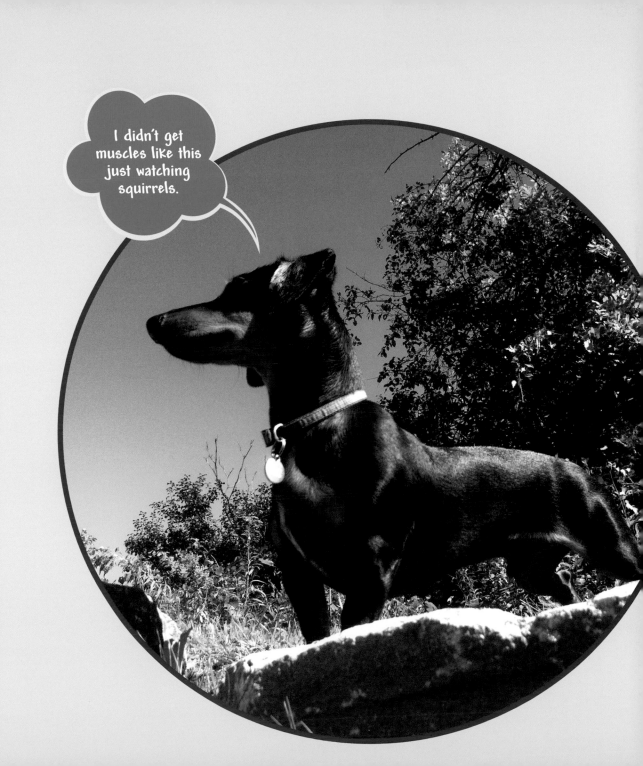

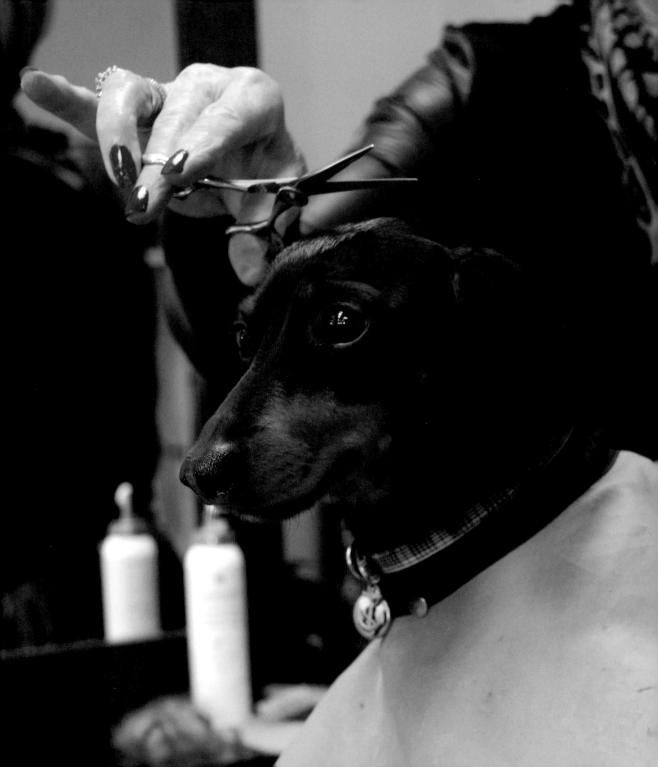

Gettin' My Hair Did

I recently decided that as a celebrity, I need to be going to a high-fashion hairstylist as opposed to the monotonous and rather typical dog groomer.

Mum made the snide comment that my hair was so short a stylist wouldn't even have anything to work with! Well, I was about to show her.

So I borrowed the car and went to the hairstylist down the street. Perhaps they're used to having high-profile celebrity dogs at their salon, because they didn't have one objection to me walking right in and hopping up onto the chair.

"So what are we going to do today?" the hairstylist asked. I was lucky to get the owner of the business; the most professional and experienced stylist in the building.

"Well," I said, "I'm going for the sex appeal of Bradley Cooper mixed with the charisma of Barack Obama and the lovely wavy curls of a Golden Retriever. So whatever you can do for me in that regard."

"No problem," she said confidently. "I have just the thing in mind. First let me see what we're working with here. . . ."

And with that she started to comb my hair.

I couldn't help but wonder if she was indeed combing my hair, or just measuring my ears in comb-length units (for what reason I don't know).

"Okay, great," she said. "I'm just going to take a little off the top now."

I made sure to hold as still as I could as I heard the *snip snip snip* above my ears.

"How's that?" she asked.

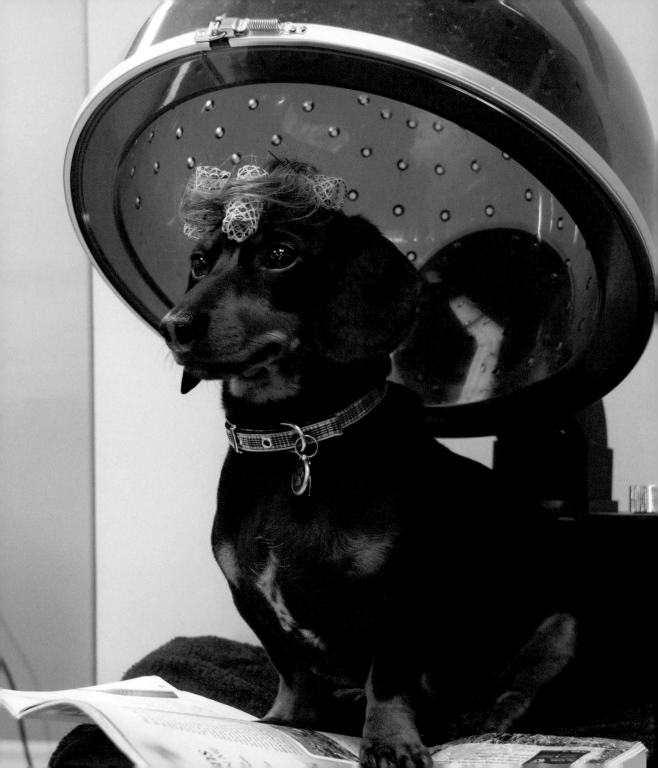

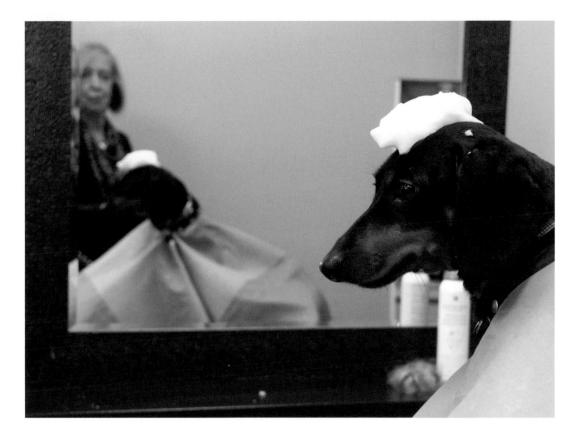

"Incredible! Wow! Looks great!"

To be honest, though, I didn't notice much of a difference.

"Okay," she continued, "now I'm going to apply the curly extensions and then lather it with mousse prior to drying. This will help define and hold the curls better."

So before I knew it, she had added the extensions and foamed the top of my head with what felt like warm suds.

She then wheeled me over and placed me under the dryer. And as the mousse dried, I couldn't help but wonder what my new hairstyle would look like!

"How's it looking? How's it looking?" I asked impatiently.

"Be patient," she said, handing me a celebrity magazine to gander over while I waited (though I couldn't concentrate on reading).

Finally, once the dryer was all done, they brought me over to the mirror so I could see my brand-new hairdo (after removing the curlers). And wow, what a hairdo!

I couldn't be happier! It was exactly what I asked for!

Can't wait to see what the chicks think of me now! Sexiest Man Alive? President? Best in Show? Heck, a great head of hair is the key to opportunity!

Keep curlin',
Crusoe

On July 1, I visit Parliament Hill of my home city, Ottawa, for Canada Day! As you can see, a few fans came out to see me.

This is more complicated than I first thought. Not to worry though, Chef Crusoe has it all under control.

Chef Crusoe

Coconut Ice Cream

One of my favorite summer treats is coconut ice cream! It's simple, creamy, and delicious! Of course it's easy enough to buy ice cream in the store, but it's always more rewarding when you make it yourself. So let me show you.

INGREDIENTS

Ice

Cream

Well, that's what I figured at least. But in fact, this is what you need. . . .

Cream (from a cow)

Cream (from a coconut)

Milk (probably from a cow)

Shredded coconut (Heck, might as well just put in a whole coconut.)

Step 1: Make Sure It's Cow Milk

The first step is to ensure you are indeed including the right kind of milk in the recipe. But between you and me this is merely an excuse to drink some milk, which I adore.

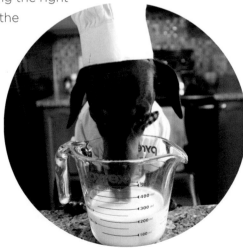

Step 2: Mix It All Together

Supposedly there's a specific order in which you need to do this, but heck, if they're all going to get mixed together anyway, I don't see what the issue is.

I was expecting there to be more to it. . . .

Step 3: Put It in the Freezer

So now, after I've so skillfully blended everything together, have a human pour the mixture into a plastic container and place in the freezer for a few hours.

In the meantime, take a break while the others clean up.

Step 4: Taste Test

The next step is to ensure it tastes good. Admittedly, I may not be the best judge of this since I find most things taste good, but as far as I was concerned, it was delicious!

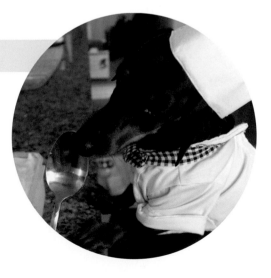

Step 5: Enjoy with Friends

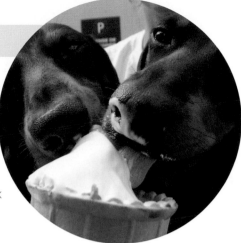

Put your ice cream in a cone, in a bowl, on the floor—however you like to eat it. Invite a friend over to share and enjoy it, preferably outside in the sunshine.

I invited my brother Oakley over to share mine with! Usually you could tell by the anchor mark on my nose which one of us is me, but in this picture it's covered in ice cream!

BTW, if you can't already tell, Oakley loved it!

Keep milkin',
Crusoe

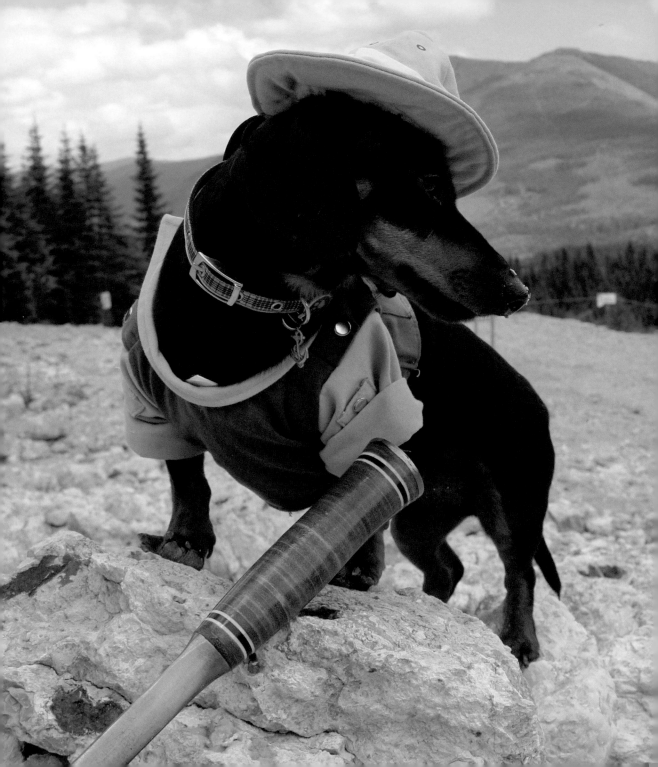

Striking It Rich

You probably didn't know that I am also an experi-enced miner, which I guess is a natural progression for a dachshund—being born diggers and all.

On a recent trip out to the east coast of Canada, we visited an open-pit mine up on the mountainside of an old volcano where the general public can come to dig for the special rocks that contain agate, a semiprecious stone.

The prospect of striking it rich drove me into a fever. But it's hard to hold a pick in my paw, so instead I started barking orders at Mum to "get to diggin', lady!"

I kept a close eye on Mum and the others for the rest of the day as they toiled under the harsh sun. I was also watchful as to any big bulges in their pants, which might indicate they were trying to conceal any

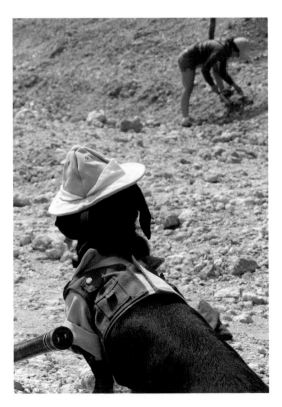

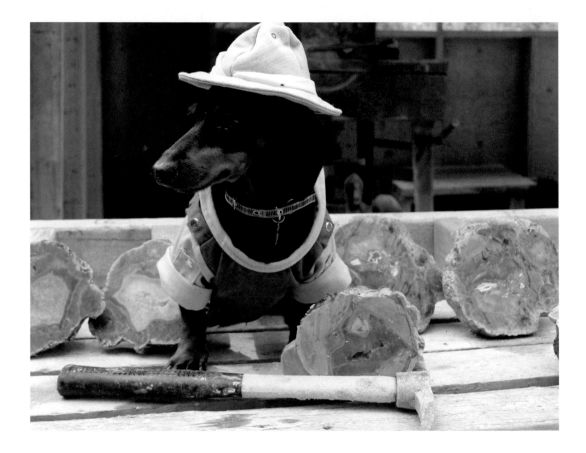

of my precious rocks. . . . Luckily they're not so easily hidden.

And when the day was done, they were all strip-searched. What can I say? I run a tight operation around here.

But look what we found! Or should I say, look what I found!

"I'm rich, I'm rich!" I told myself. That is, until someone explained to me they aren't as valuable as diamonds, whereupon my fever wore off and I returned to my somewhat more mild-mannered self.

Ah well, a great experience and a great new memory of my many travels to adorn my living room!

 Keep toilin',
Crusoe

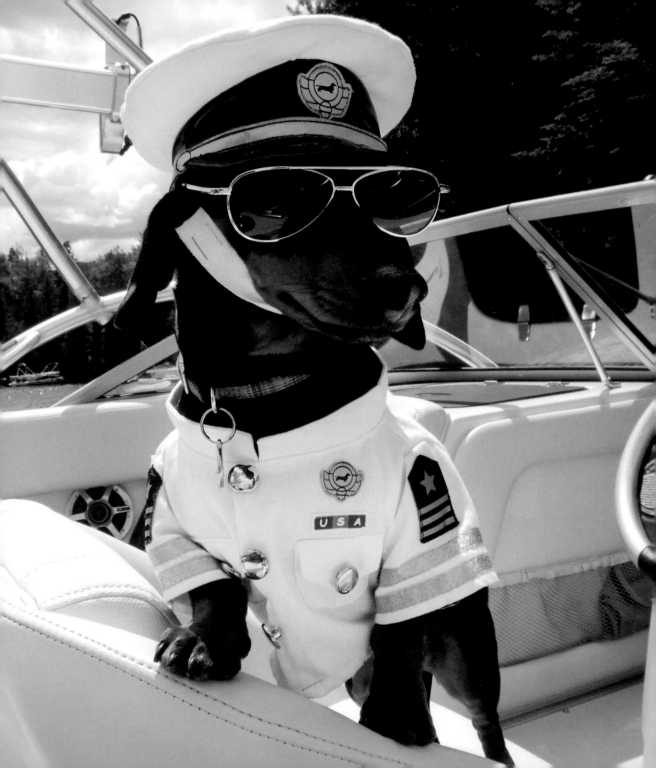

Captain Crusoe

Introducing Captain Crusoe—sailor of the seven seas, slayer of sea monsters, seducer of exotic señoritas, and all-in-all, the sexiest darn wiener dog captain you've ever seen.

You can tell I'm a born sailor because of the anchor-shaped birthmark on my nose.

I'm always ready to welcome just about anyone aboard my ship (except cats) as long as you follow a few rules:

- There is only one lifeboat available, wherein all the sexy ladies (and myself) will be saved first in case of an emergency.

- Under no circumstances will the captain go down with his ship. I still have way too much to live for.

- Do not touch, take, or even ask to wear the captain's hat. It is the sole property of the captain (me).

- The onboard fire extinguisher is a prop only. In case of fire, do the obvious and use the frickin' water around you.

- The onboard safety whistle is strictly for whistling at babes from afar, and the air horn is for the babes that are *really* far away.

- Only the captain drives the boat, and only compliments will be accepted about his driving/sailing skills.

- Generous gratuities are mandatory upon the end of the trip, and will

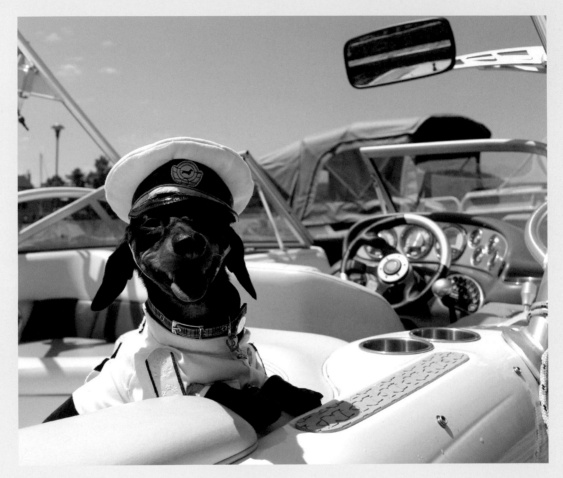

be accepted in the form of squeaky balls and/or treats. Persons failing to proffer tips will be forced to wash my poop deck.

• Terminology: stern means "I'm serious"; port means "open me a bottle of wine"; starboard means "hottie ahead"; and bow means "the front of the ship" (obviously).

My adventures as captain have taken me far and wide.

I've driven power boats on freshwater lakes. . . .

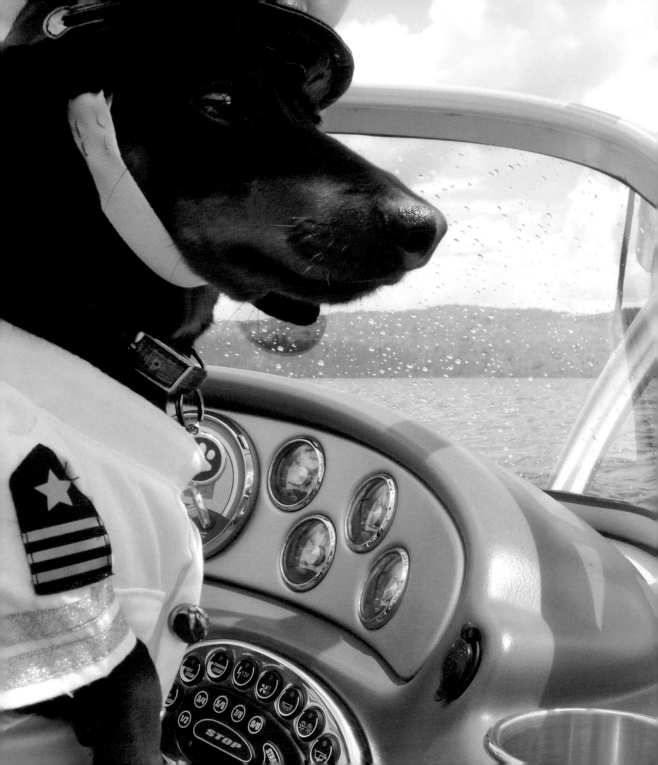

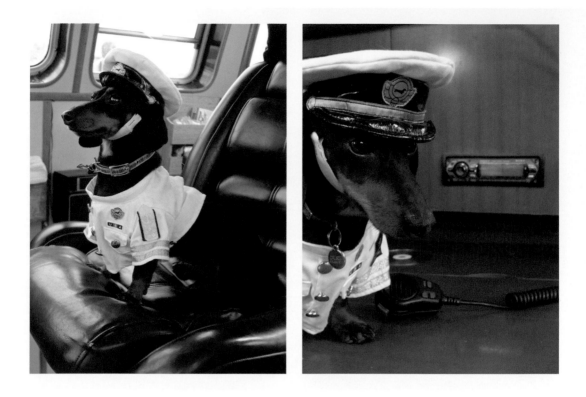

I've sailed yachts through the narrow straits of the Bahamas. . . .

Heck, I've even piloted large tour boats off the Atlantic coast while giving a spiel on the natural landscape to fifty or so people aboard. (I got a lot of tips that day.)

Many ports across the globe now recognize the revered name of Captain Crusoe.

I've only ever had to call mayday once,

which was when I ran out of squeaky balls aboard the ship.

It was a close call, but luckily an emergency supply was subsequently delivered by the Coast Guard.

Keep sailin',
Crusoe

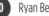

Beware—Long Body Crusoe—the pirate wiener dog! Scourge of the seven seas; seducer of even the most imaginary of mermaids; devilishly good looking; and with an insatiable appetite for digging up buried treasure (but mostly just for digging in general).

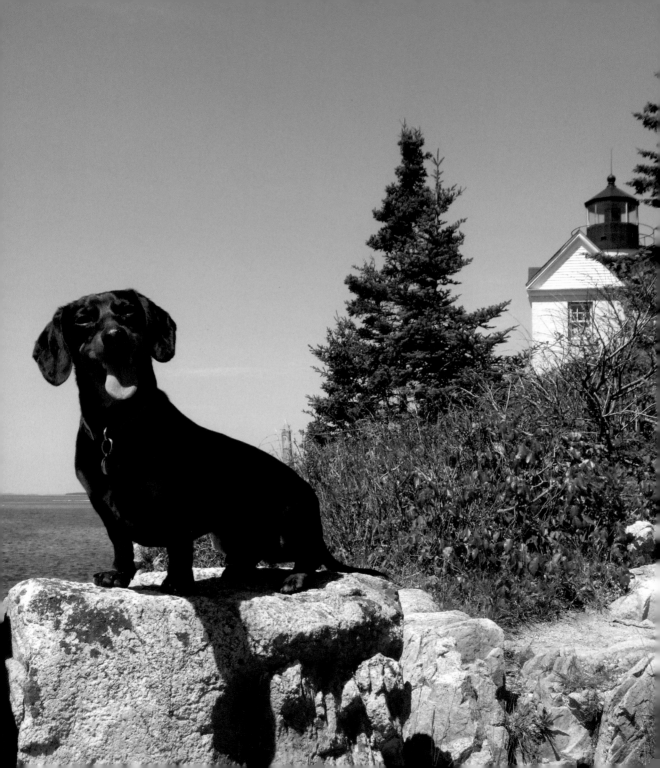

Vacation to Maine

Once I got my first taste of traveling, I had to have more. My next trip was to the beautiful state of Maine, where I rented a private home for me and the family—away from the paparazzi and hubbub of the city.

Maine is a wonderful place if you ever get a chance to go. We spent the first few days exploring, hiking, and just relaxing in the sweet sunshine and cool breezes from the sea.

One day we took a trip to a lovely beach. Who knew Maine had beaches like this?!

My first goal was to scope out my surroundings to see if there were any hot babes around (it's called situational awareness, btw).

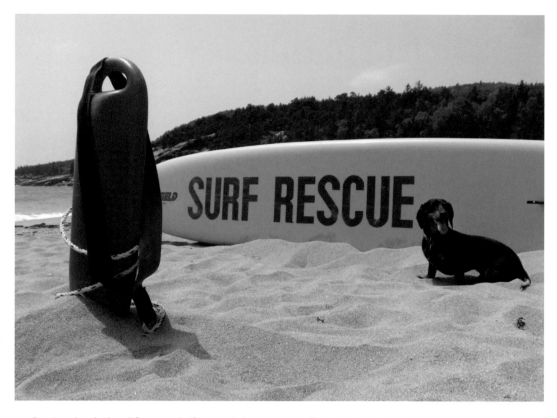

So I asked the lifeguard if I could use her tower for a bit, and she agreed.

I was, however, disappointed to see there were few to no chicks around. (Then again, this is Maine, not Miami.)

BUT, I know being a lifeguard is a common babe-magnet job in itself—like firefighters, superheroes, captains, etc. So I had to at least pose for a nice postcard pic.

The following day I learned that Dad had set some lobster traps for us when we first arrived, so it was about time to go check on them!

The misty morning combined with the salty smell of the sea was tingling my fisherman's senses! My excitement was building, and I was anxious to see what type of fish we were going to catch!

However, when Dad started pulling in a rope from the water, I couldn't help but wonder, *What the heck kind of fishing is this?* This isn't how we usually do it. . . .

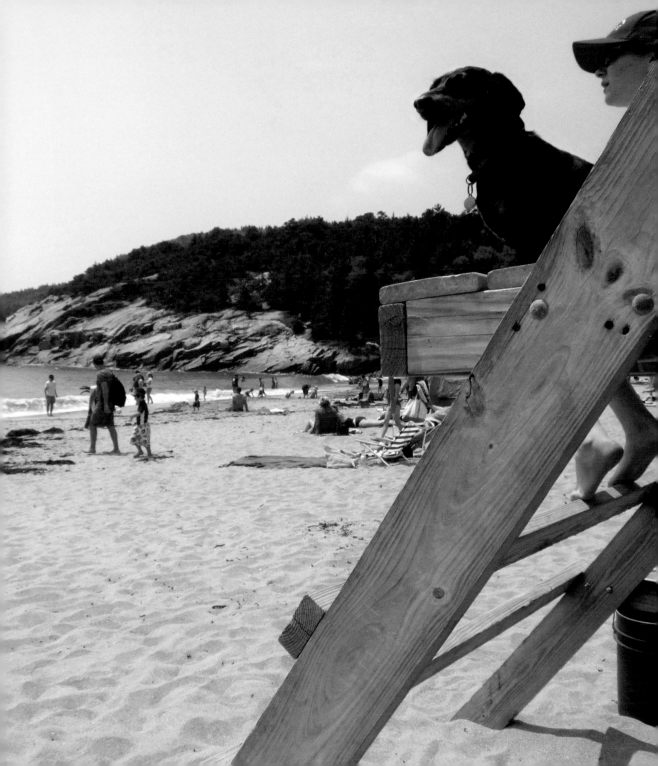

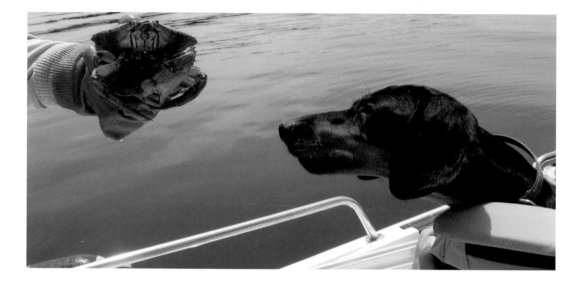

But I was curious nonetheless.

And look what it was! A big nasty spider—hey, that's not a fish!

After a quick disdaining sniff, I told Dad to get it away from me, so he threw it back in.

But after we pulled in a few more cages, we finally pulled in the "prize," according to Dad, which, to my disgust, once again was an even bigger and uglier bug.

The worst part of all was that they actually said this bug was a delicacy! Dad said I'd be crazy not to like it.

Sorry, but this one's not for me.

My opinions were later justified when I did some follow-up research and learned that a long time ago, lobster was fed to prisoners along with fish tails because of their undesirable nature!

Well, I guess I'm not crazy then.

All in all, Maine was a beautiful place and I'd love to return one day. In the meantime, hopefully they can sort out this lobster business.

Keep ~~lobsterin'~~ vacationin',
Crusoe

Rub my belly or throw the ball, it's your choice.

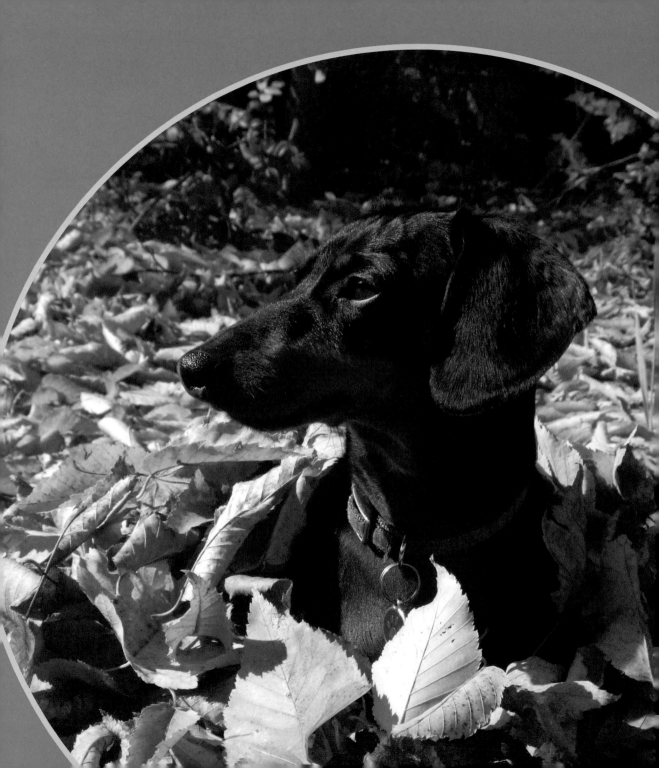

FALL

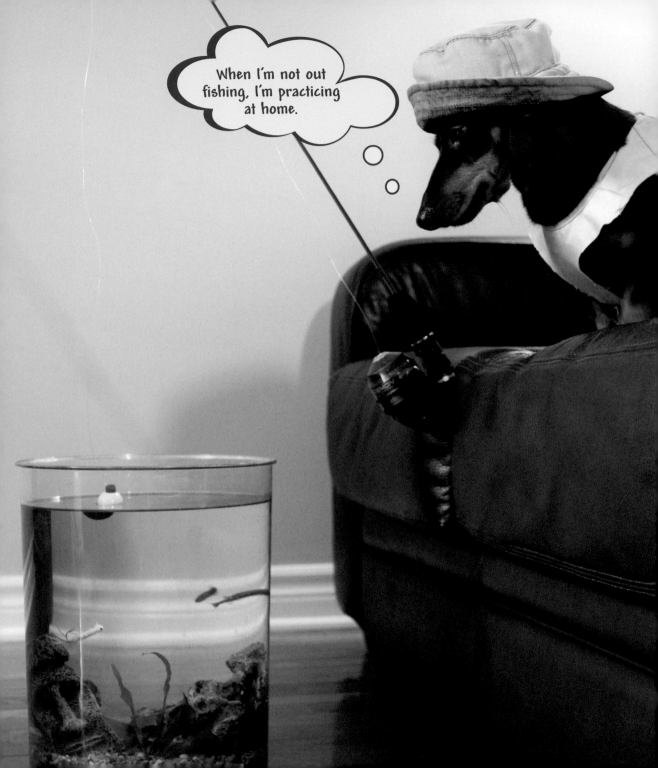

Fishing

One of my favorite fall activities in the whole wide world is fishing. I'm not even kidding—I don't joke about fishing. There's just something about the mystery of the water and not knowing exactly what you might pull out of its depths that I really love.

Ever since my Uncle Jack took me out for the first time, I've been totally and hopelessly obsessed. I have a tendency, *er* . . . a compulsiveness to get overly excited, so much so that I start whining and squealing with utter exhilaration. Mum uses the word *cuckoo* to describe me.

When I see Uncle Jack getting his rod out of the shed, I'll run down to the dock and wait by the fishing boat. Or sometimes I'll just go wait beside the boat anyway to tell them I want to go!

Once we're on the boat, I'm incredibly

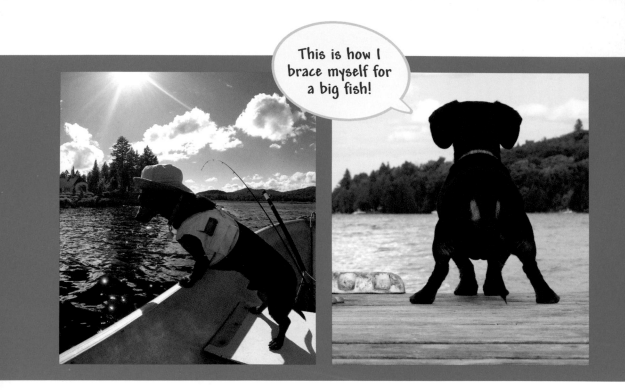

This is how I brace myself for a big fish!

impatient, which I realize is somewhat contradictory to the whole idea of fishing, but I just can't help it.

The whole time I'll be hanging over the side, whining with anticipation and impatience. Mum and Dad say my high-pitched whining and occasional squeals are bound to scare away all the fish before I even get one, but again, I can't help it.

"Here fishy, fishy, fishy . . ."

I'm what you might call, a real fishing bum.

We could be out fishing for hours, and I'd still be as into it at the end as when we first started. I bet not many people can say that!

I'm very conscious of proper technique (in others), though. I will watch every cast the humans make, watching for the little splash at the end, and will criticize them when not done to my standards.

Again, I'm a very impatient fisherdog and have no time to waste on sloppy casts.

Here I am fishing with Mum from a pier in Eastern Canada.

I don't know what the heck she finds to be so amusing. She should be concentrat-

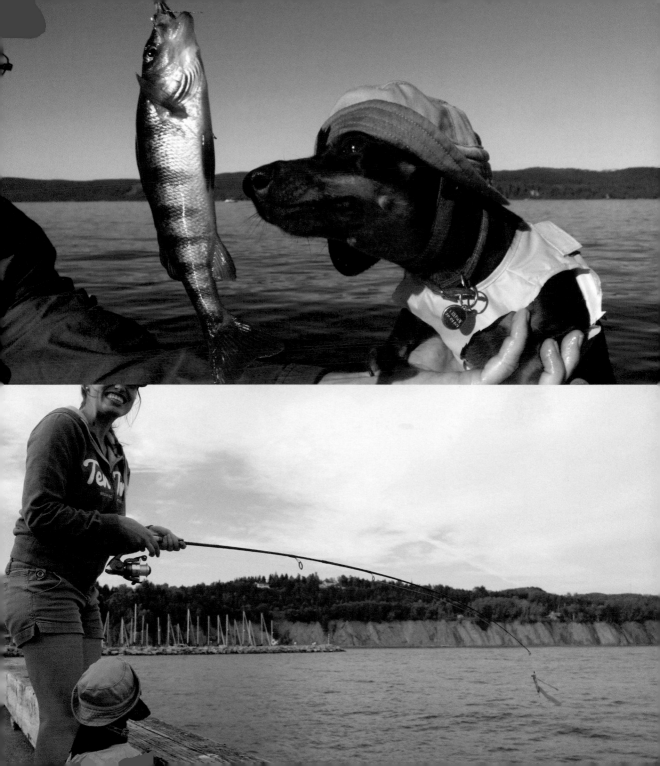

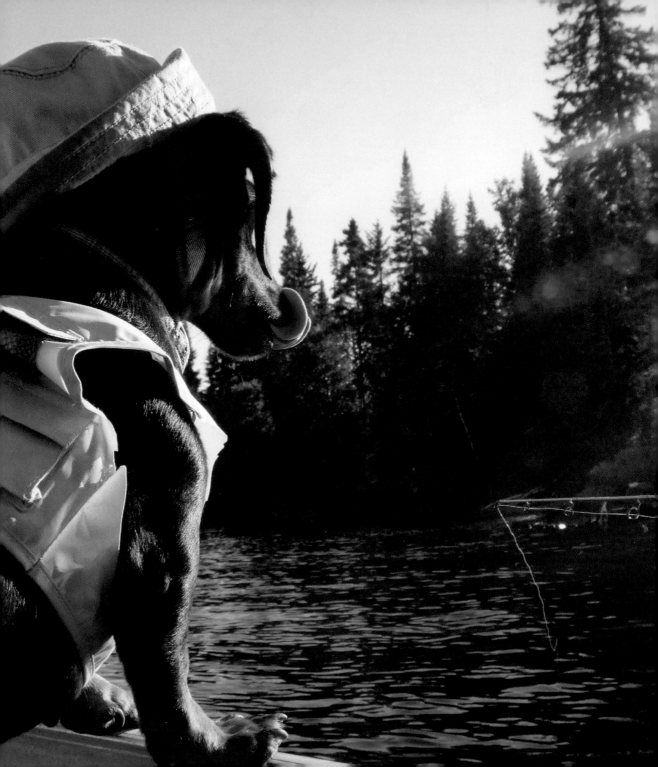

ing on properly baiting her hook and not looking like a doofus.

The truly exciting part though, is when I hear the *zzzzzzzzzzzzzzzzzzzzzzzzzzzz* of the line being pulled out followed by someone shouting, "FISH ON!"

It's at this point that I become utterly uncontrollable, barking out ear-piercing shrieks of pure, unadulterated excitement that can be heard from across the lake.

In fact, if you were to go fishing with me, I would be otherwise unbearable if it wasn't for my impeccable cuteness and muscular physique for you to admire.

In fact, this is often where the photos end because every man aboard the boat has to either be concentrating on a) reeling in the fish, or b) restraining me from jumping over the side. In fact, Mum and Dad say they have a harder time keeping me from jumping out of the boat than reeling the fish into the boat.

And when the fish is finally in, I just want to bite/lick/admire/inspect/fry it up!

I could watch those fish forever!

I've even tried to bring my brother Oakley along to share in the excitement of reeling in a big one!

However, although he is enthusiastic about trying new things, I don't think fishing is his passion. In fact, I think he

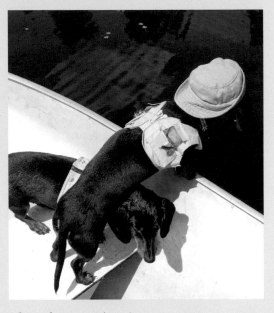

often forgot what it was we were even looking for!

Oh well! The nice thing about fishing is that it can very easily be an individual sport. And I don't mind it that way, because as much as I love my bro, he's kinda crampin' my spot here.

Keep fishin',
Crusoe

September is when I get kisses from Mum in the sunflower field, a new yearly tradition of ours!

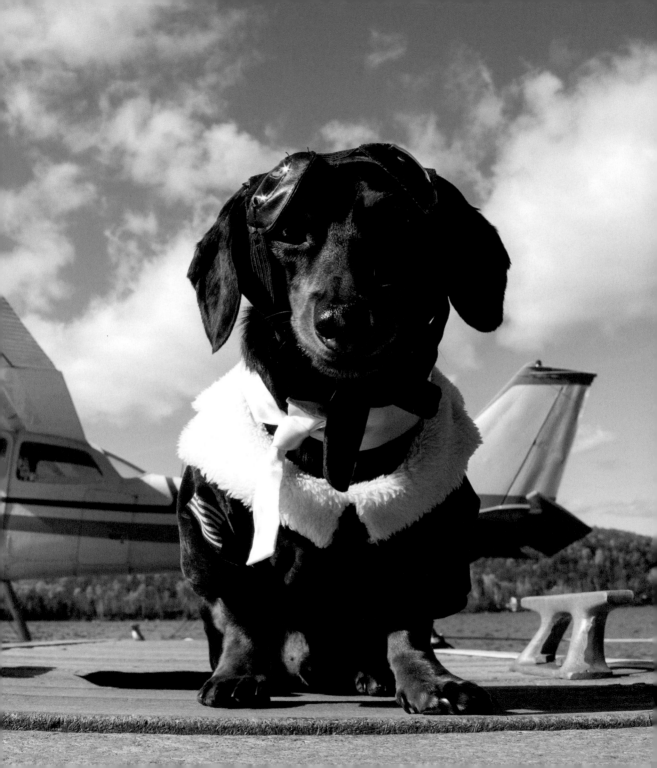

Crusoe the Pilot

One of the most recent titles on my résumé is accomplished pilot.

I wanted to feel what it's like to have "liftoff"—you know, to see the world from up above, to float through the clouds like a bird.

So I did what any celebrity does when they want something. I whined to Mum and Dad until they bought me what I wanted—a pontoon plane.

I also took a few flying lessons online and was excited to take my plane up for my first-ever flight as pilot!

Eventually I'm going to have to get a booster seat installed in here, though, because once again, human ingenuity

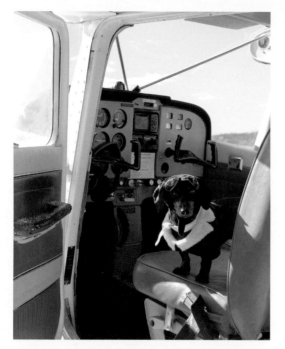

fails to consider the needs of small dogs like me.

I'm sure it'll be fine, though.

So, are you coming?

And of course, I'm all about looking good while I do something, so I'm sporting the characteristic pilot outfit—even if the goggles are just for show.

I sat on Dad's lap and had a copilot with me who could occasionally take over to allow myself some time to pose for photos between flying the plane.

I verbally ran through the checklist to make sure we were ready for flight, re-membering everything I'd learned in flight school.

Crusoe: Do I look good from the right?

Copilot: Check.

Crusoe: And the left?

Copilot: Check.

Crusoe: How about from above?

Copilot: Check.

Crusoe: From below?

Copilot: Check.

Crusoe: Is there a parachute for me?

Copilot: Check.

Crusoe: Do we have some sort of snack for the way?

Copilot: Bacon bites, check.

Crusoe: Sexy and I know it? Check! Check! Check!

So with the plane ready for takeoff, I revved up the engines and kicked it into gear (I believe that's the right terminology) to start us moving across the water.

It felt like we were gliding across butter! (Mmm . . . butter.)

And before I knew it, I was in the sky, soaring like a bird!

It was an incredible experience. You

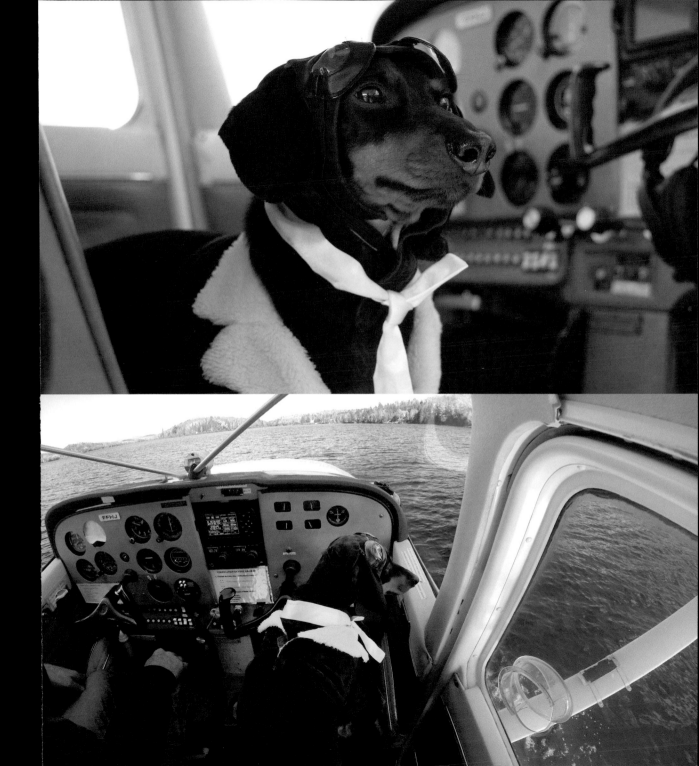

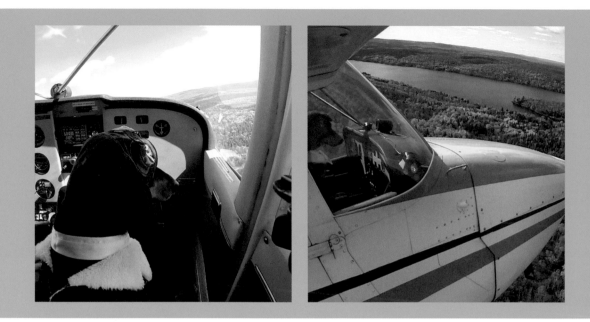

would think a little dog like myself might be scared, but, no, I was ever so curious to see the world out the window, to smell the light scents of the clouds, and to admire my kingdom from my new throne in the sky.

I might even go as far as to say that I'm an "ace" pilot. Check out how good I look flying this baby!

And finally, I took us in for a perfectly smooth landing on the lake to wrap up my first successful flight.

Mum and Dad were very impressed, as I expected. I was pretty proud of myself, too.

However, now that I think about it, the online flight school I attended may have just been a modeling course that happened to have a pilot as the model. . . . Oh, well, seemed like I learned something about "being fly" anyway!

So if you'd like me to take you up for a quick tour sometime, just let me know. As long as you bring a camera and take some good pictures of me, there's no charge.

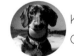

Keep flyin',
Crusoe the Pilot

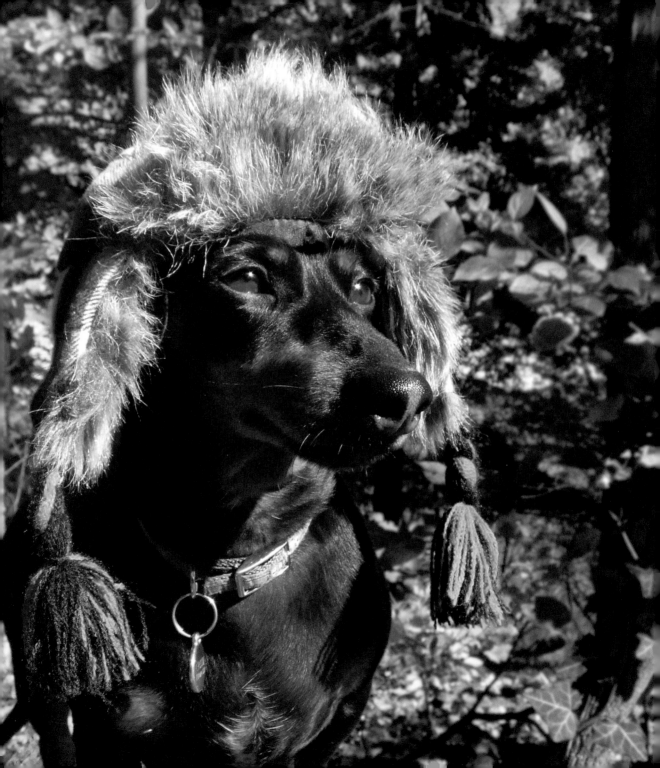

Gone Duck Huntin'

Fall is duck huntin' season, which is something I look forward to every year. However, my intention is not to shoot or eat the duckies. I just find their squawking and trespassing quite annoying, and so I pretend to be a big bad hunter to deter them from my land.

So every year around this time, I put on my ol' Elmer Fudd huntin' hat and get ready to show those ducks what it means to come around my turf.

I set up a little decoy, put on my camo, and wait with my pretend rifle in the brush.

You have to be vewy, vewy, quiet.

My goal is to wait for them to come around, all unsuspecting-like, and then pounce out of the bushes to scare them away once and for all.

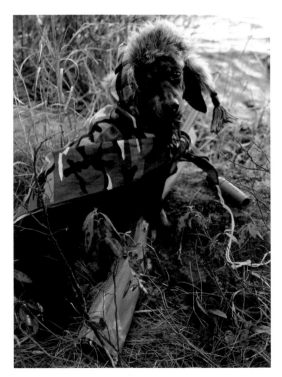

And so I wait . . . and am even somewhat patient at first.

Yet after a while I noticed that the ducks were coming in to the other side of the dock—but not where I was with my decoy. There was something strange going on. . . .

So I left my position and went around to inspect what might be drawing the ducks over there.

And you wouldn't believe what I saw! There was Dad, without a care in the world, throwing pieces of bread to the ducks!

Can you believe that?! I'm trying to scare away the dang things and he's there inviting them over for brunch!

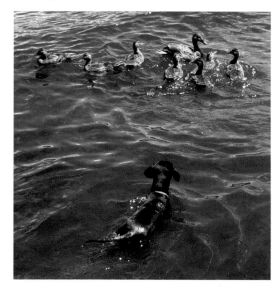

So there was only one option. I had to get in the water myself to chase them away.

It didn't work, though—the ducks kept swimming around me and grabbing the pieces of bread that Dad was throwing. I realized chasing them wasn't going to work. So, I turned around in place, just in front of the ducks, but now facing Dad. Time for Plan B. I started to catch the pieces of bread myself and eat them before they reached the ducks.

Ha! That showed Dad, and the ducks! Now that's strategic thinking!

Eventually, I consumed all the bread Dad threw, and the ducks got bored and left. Mission accomplished.

I was disappointed with Dad for helping the ducks like that. After the incident, I explained to him how feeding the ducks bread can fatten them up to the point where they can't fly south for the winter (which means we'll never get rid of them!).

He of course made the smart remark that I was the one who ate most of it. . . .

Argh.

 Keep duck-huntin',
Crusoe

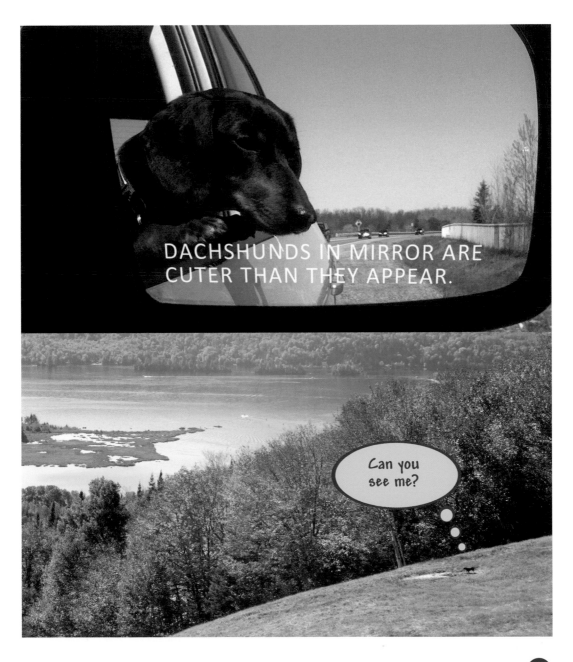

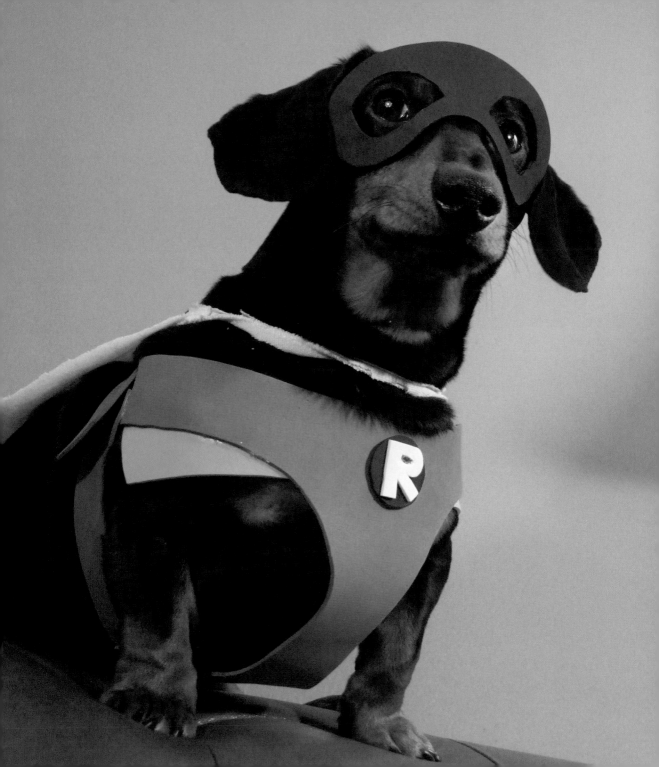

BATDOG and Robin:
The Goofy Brother Rises

It wasn't long after I became who the world now knows as BATDOG, that I realized I needed some help. I'm too busy to do this BATDOG thing all by myself. My phone is always ringing off the hook from chicks who are "supposedly" (extra emphasis) in need of saving, and as much as I'd like to, I just can't get to all of them!

I guess you could say BATDOG needed a wingman, so to speak. And thus, I asked my brother Oakley if he'd be interested.

As I might have expected, he jumped at the opportunity to be Robin!

And so the forever duo was formed, sworn to protect the world from dubious cats and criminals (generally one and the same), and to save damsels in distress.

Always waiting, watching, and ready for an opportunity to leap into action!

We're not your typical superheroes, though—BATDOG is motivated by fame and glory, and Robin by brotherly admiration and shiny things.

So every now and then Oakley and I get together for our routine patrols of the city. You know, to watch the city for any suspicious activity. (Essentially, go cruising for chicks.)

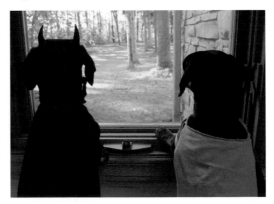

Since there's now two of us, we both can't fit on the BATBIKE, so once again we need Mum to drive. This is rather bothersome, as she never obeys my commands to honk at the ladies we pass by.

Anyway, we may be "wiener" dogs, but it takes more than a hot dog bun to scare us.

It's not uncommon for you to see BAT-DOG & Robin clandestinely standing watch over some of the city's hardest neighborhoods, just waitin' for trouble to go down.

I'm sure we've prevented several drug deals from taking place just by being there.

Anyway, my research has told me that bad guys (especially cats) tend to hang out in alleyways, so a dark and gloomy alley was our next checkpoint.

We didn't find any cats, but we did manage to scare away a few pigeons, which as I informed Oakley was "work well done" in my mind.

It was then that we headed farther downtown to a busy corner, where we roosted on a ledge, posing for people passing by with their cameras—putting on our best show of looking like we were hard at work watching for crime.

Again, we're in this more for the

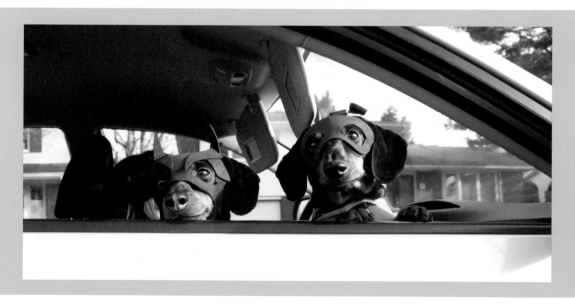

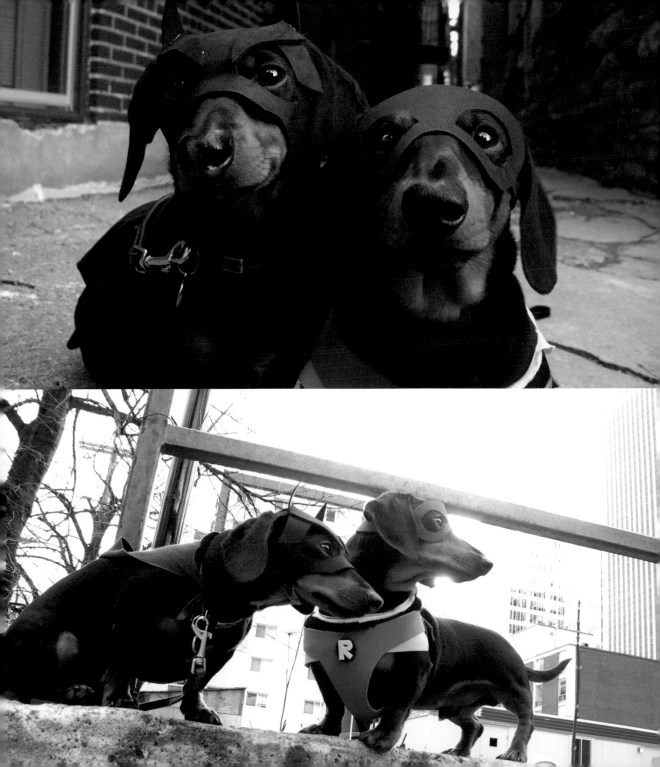

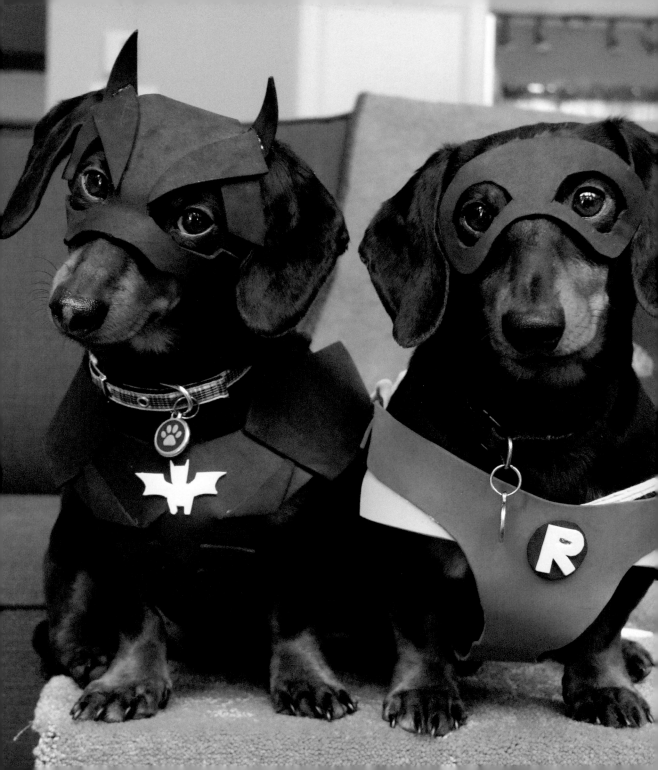

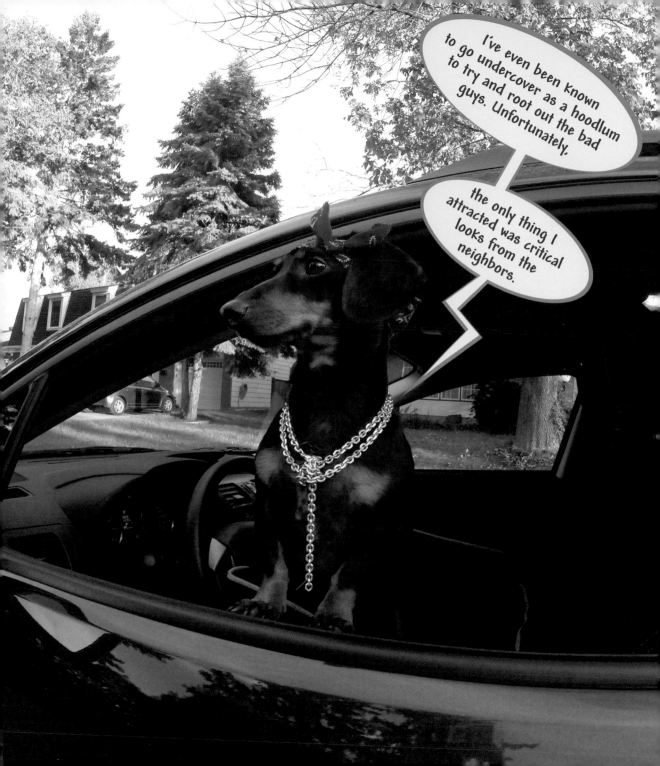

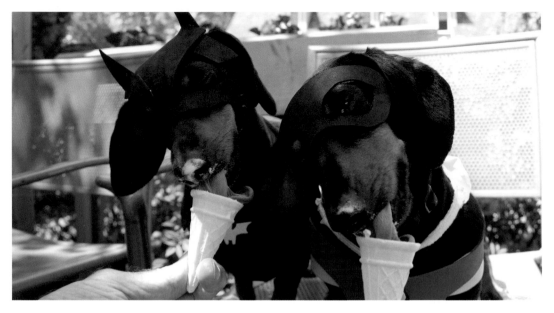

publicity than anything, so taking time for a few good photos is all part of the job.

A good photo of us chasing a bad guy means more to us than actually catching him.

Despite not solving any real crimes or picking up any chicks in the process, we were both exhausted from all that running around.

So we decided to stop for some ice cream on our way back home. As a super-hero, I expect to be rewarded for every effort I contribute to the greater good, however subtle.

You can tell Oakley and I make for a good team, as we're even synchronized in our licking!

But being the chunkier one between us, it wasn't long before Oakley had fin-ished off his cone and begun eyeing mine!

So remember folks, if you ever have an emergency, make sure to call your local superdogs—BATDOG & Robin. Just keep in mind that sexy ladies and influential re-porters will receive preferential treatment.

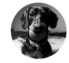 Keep needing savin',
BATDOG

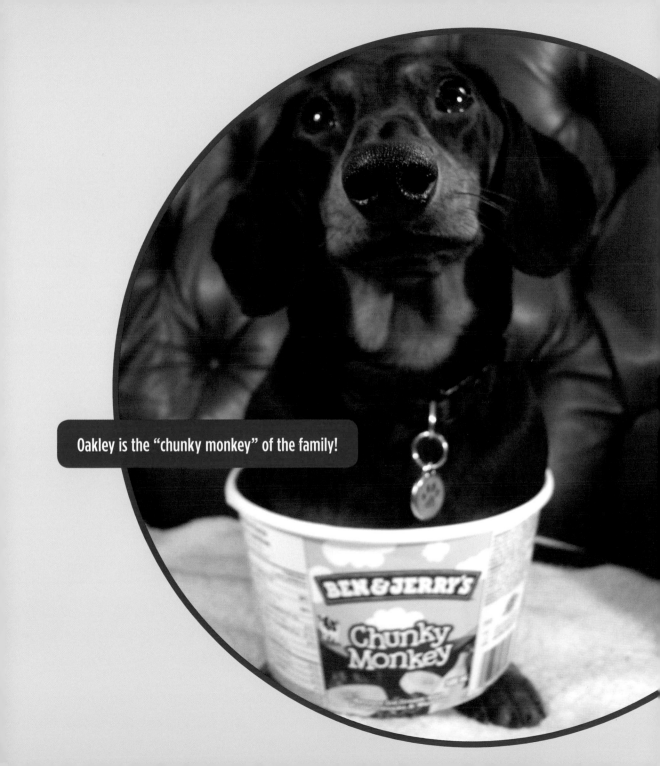

Oakley is the "chunky monkey" of the family!

October 28 is my birthday!

I make sure to give Mum, Dad, and my fans my birth-day list far in advance and provide regular reminders so there are no excuses or delays for my presents.

On the left is me posing for my birthday party invitation card!

You should also know that my expectations for my birthday grow exponentially each year.

At first I was content with just a little cupcake and a single present at home.

A year later I received a whole cake made in my own image.

The year after that Mum and Dad planned a whole surprise party with cupcakes and presents! (and friends—see page 108).

So I guess you could say Mum and Dad

have their work cut out for them for next year!

Keep partyin',
Crusoe

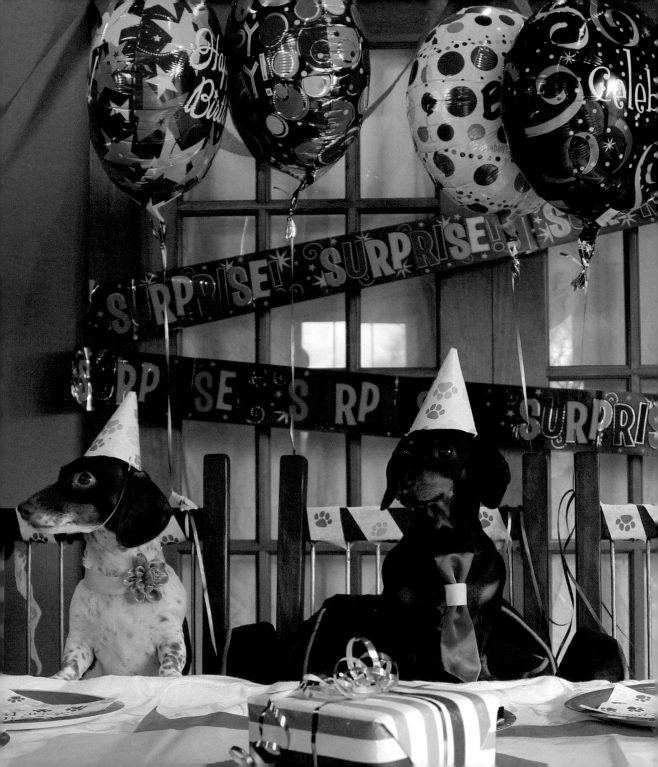

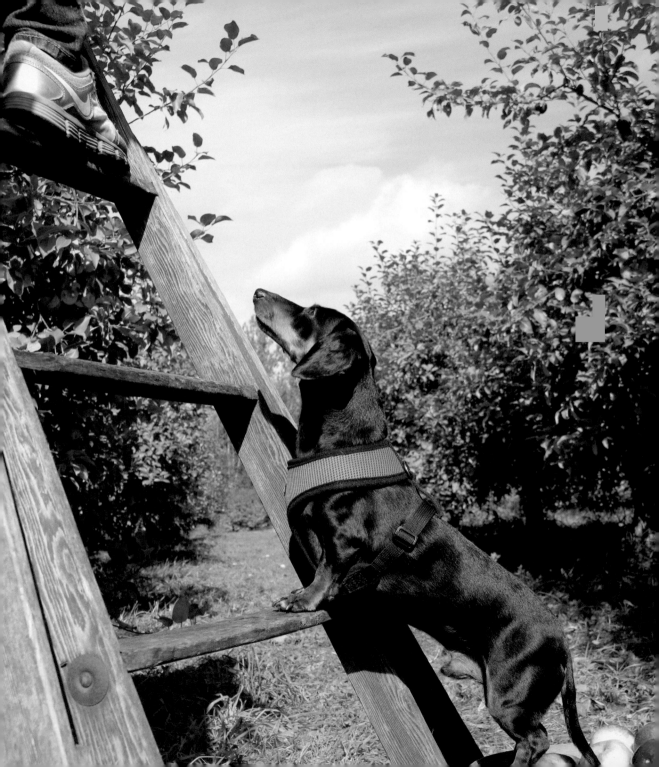

Apple Picking

Apple picking has become a yearly tradition of mine. It's a great dog-friendly activity for the whole family. I love it because it's a new environment to explore; there're plenty of juicy apples to chase and chew, and at the end Chef Crusoe gets to cook up something delicious!

Apple picking is also a popular activity with the ladies. So it gives me a great opportunity to show off my shining muscles as I haul around bushels of apples like a studly farmer.

I am unable to climb ladders, though, so instead I stand on the bottom rungs and bark orders at Mum for which apples to pick.

Again, while flexing.

As we move along from tree to tree,

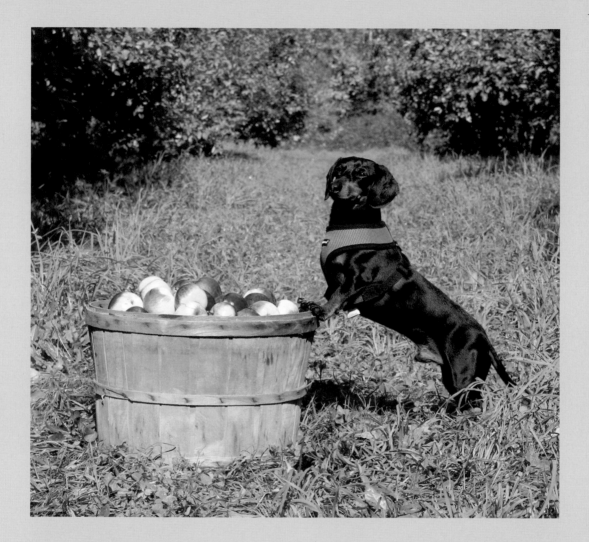

I have Mum pass me down one sample apple so I can assess the flavor before we start pickin'.

"Yep, these ones are just the right balance of sweetness and tartness, and will be perfect for what Chef Crusoe plans to make with them!"

 Keep pickin',
Crusoe

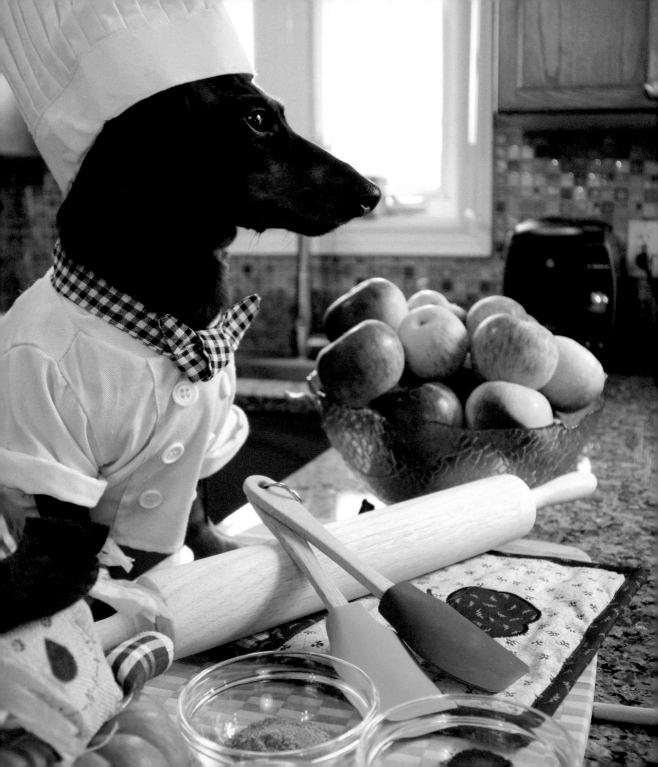

Chef Crusoe

Apple Bacon Pie

With my freshly picked apples from the orchard, it's time to make something special. An apple pie is a bit bland by my standards, so I'm creating a new spin on it that will make it much more delicious!

Today, I, Chef Crusoe, will be making an apple bacon pie, entirely from scratch!

INGREDIENTS

A bushel of apples (It's recommended you take off your shirt while hauling it around to showcase your muscles.)

Lots of bacon (Please put your shirt back on before sampling the bacon.)

Various exotic powders that smell funny (Or as Mum says, cinnamon, ginger, nutmeg, and flour.)

Deliciously fatty butter and shortening

A pumpkin man for decoration (i.e., a scapegoat for any errors).

Step 1: Proper Proportions Are Pointless

Okay, so the first and most boring step is to mix together all the magical powders. Now, most people will tell you this is where it's important to measure out the right amounts. But as I always say in cooking, "proper proportions are pointless," because you'll never learn to be a good chef if you can't develop a "feel" for what should be the right amounts of everything.

You may find it more fun to pretend you're a sorcerer while you do this. So without even looking at a recipe, I instinctively know this needs a dump of white stuff, a scoop of brown stuff, a pinch of grey stuff, and a flick of the other brown stuff.

And while fluffing around all those powders, keep in mind it's likely you'll end up with some on your body's extremities. In my case, my nose—which isn't so bad, especially considering I'm not even wearing pants.

Step 2: Turn It Up a Notch

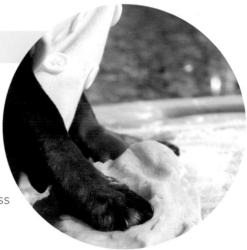

Now we chunk up some of the shortening and add it to our bowl of powders, to then be added to the mixer.

You'll notice there is a switch on the side of the mixer with number intervals from 1 to 10. Now I don't know exactly what these represent, but whenever I see a sliding scale up to a number 10, I can only assume it's a sexiness rating.

And obviously, I'm a solid 10 out of 10. You might want to choose something more conservative like a 2 or 4, though.

Step 3: Straight Kneadin'

Now we have to "knead" the dough, which is something I am quite good at. You'll want to roll up your sleeves and really get in there.

If you're a human making this recipe, I would really recommend you get a dog to do this part, because our paws have a certain saltiness that really adds a lot of flavor to the dough.

Step 4: How I Roll

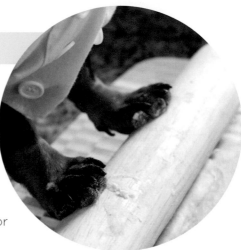

Once we've really worked in the dough with our paws, we spread it out on the counter, sprinkle with more white stuff to prevent it from sticking, and roll it out with the big round stick—but don't chew the stick.

Then, a good little tip is to lick the dough you've just rolled out. If you taste the lard flavor then it means we're doing it right.

Step 5: Don't Forget . . . !

Now we lay out the dough in our pie pan, getting ready to add the apples and bacon— which reminds me, I have to prepare those now. That dang pumpkin man was standing in front of the apples, so that's why I forgot.

Step 6: Peel the Apples
(Should Have Done This Earlier)

Now comes the tricky part. We have to peel all the apples. You might need to take off your hat for this one, because it can get messy—and sticky.

Despite my best efforts, peeling apples is not the easiest thing for me.

So since this is just a straightforward, tedious task, I would just have a human do it. (i.e. Mum)

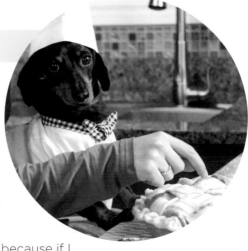

Step 7: Add the Apple Filling

Now we can pour the chopped apple filling into our piecrust. We want to make sure it's nice and full to the top, but that there's still room for our bacon top.

Now for the best part. We need to carefully thatch the bacon over the entire pie to create our top.

I had to have Mum point this step out to you, because if I get too close to it, I don't trust myself not to snatch a bite and possibly ruin all the work I've done this far.

If you're as tempted by bacon as I am, you may wish to have someone hold you back at this point.

Step 8: Into the Oven

Now we can finally put our pie into the oven, safe away from me trying to snatch a sample bite.

Again, I'm not about exact measurements. An experienced chef can tell when the pie and bacon are cooked just by the smell!

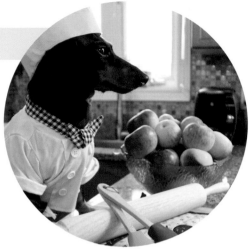

Step 9: Finito!

Et voilà! Behold my beautiful, sweet, savory, and crispy apple bacon pie—made with my own two front paws and no pants!

 Keep peelin',
Crusoe

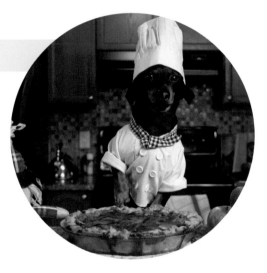

May I have another slice, please? I'm being polite, but that wasn't really a question.

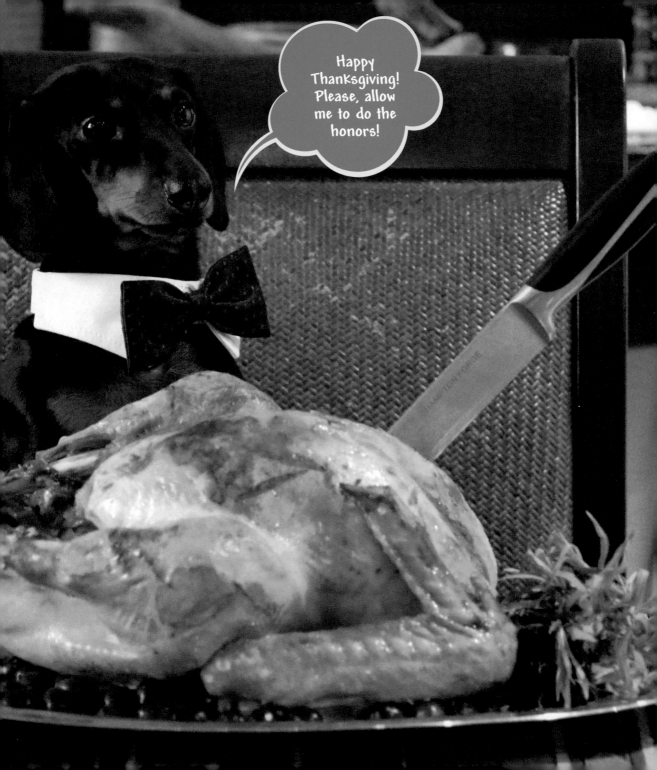

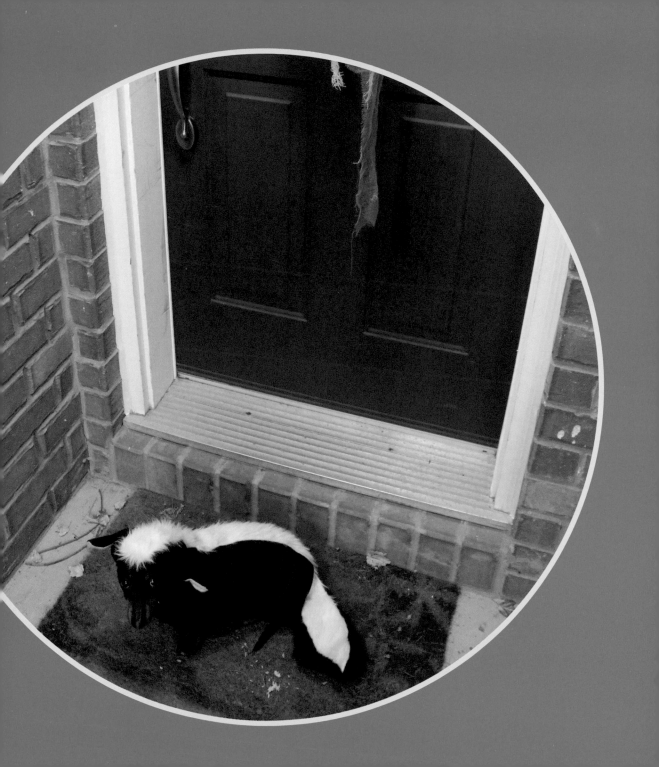

Halloween Costumes

I am quite renowned for my Halloween costumes. And I'm not even talking about my alter-ego outfits like that of BATDOG, Chef Crusoe, etc. What you see here are strictly "costumes."

I would also like to clarify that although I enjoy dressing up in my various costumes, I am not a proponent of the whole trick-or-treating thing.

In fact, I despise it, and I think most dogs are with me on this one. Like seriously, who enjoys having their doorbell rung over and over for an entire night? I for one cannot tell the difference between a trick-or-treater ringing our doorbell and a burglar ringing our doorbell—so I have to react the same way regardless, which is barking my head off.

However, as I am smarter than most people, I had a different plan to deter those stinky-bottomed little kids from knocking on my door.

I waited outside our front door in my realistic "skunk" costume—but not to showcase the costume—no, my goal was to convince people I was a real skunk and therefore discourage anyone from coming near me or my home.

And it worked.

Now let's take a look at some other costumes of mine. . . .

Sexy Vampire

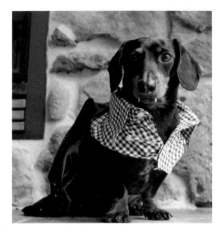

Nowadays, handsome vampires are all the rage, following movies such as *Twilight* and the like. However, I found it unsettling that there was this whole mass-market group of chicks with a fancy for vampires that I wasn't catering to.

Well, until now.

Here I am as a handsome vampire—perfectly groomed, chiseled physique draped in a cus-tom-stitched Armani cape and collar, and immortal.

WienerWolf

Subsequently to the above, I also learned that there's a certain submarket of women who prefer the wolf hunks over the vampire hunks. I'm not one to let a niche go untapped, so along came the big bad WienerWolf.

However, part of my motivation for WienerWolf was also to address the local squirrel problem. Lately, they just haven't been taking me seriously enough for some reason, so I've had to step up my fear factor a notch.

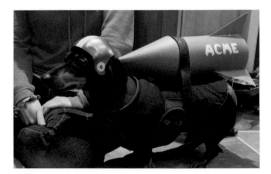

Wile E. Coyote

Wile E. Coyote is a great costume because it lets me go really fast while on a skate-board; plus chicks are always coming up to me asking to check out my rocket.

Airplane

As you know, I am already an accomplished pilot, but I enjoy it so much that for one Halloween I decided to dress up as a plane—the same sort of plane that I flew myself!

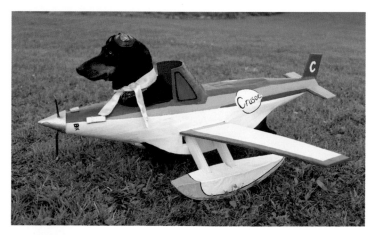

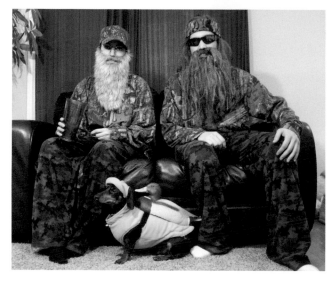

Duck Dynasty

Here's Mum, Dad, and I dressed up as Si, Phil, and a duck decoy, respectively, from the popular *Duck Dynasty* TV show.

I wanted to be one of the hunters, but supposedly I make for a better "decoy" due to my size. Pff.

FrankenWiener

Most recently I was FrankenWiener, somewhat playing off of the whole zombie phenomenon right now!

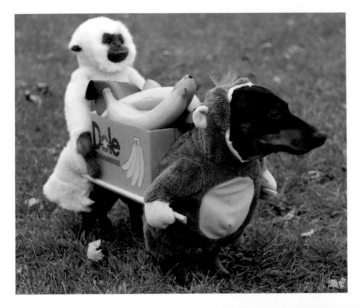

Two Monkeys Carrying a Box of Bananas

This is a prize-winning costume, inspired by the fact that Mum calls me her "little monkey."

Little Drummer Boy

Okay, this costume wasn't for Halloween, it was for Christmas; but it still got a lot of love from all my fans when I performed my drum solo.

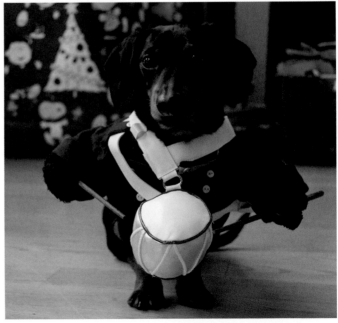

WINTER

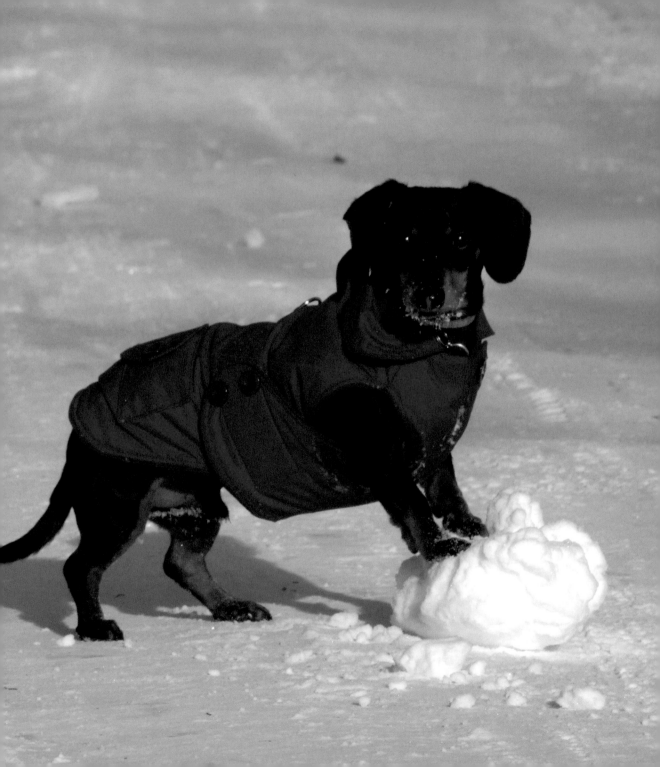

Snowballin'

I'm no stranger to the snow or cold, and in fact, it's one of my favorite times of the year!

The main reason I love winter so much is . . . snowballs. Yes, snowballs.

I love to chase them, crunch them, and munch them.

When I see Mum or Dad bend over to start packing a snow-ball, I get almost as excited as I do for fishing! Meaning, I start shrieking, squealing, and bark-ing with delight!

In fact, I get so excited that I'll rush over and try to bite the snow-ball before it's even finished being packed, meaning Mum and Dad have to watch out for their fingers! Actually one time at the park, a little girl started making a snowball, and Mum and Dad

almost had a heart attack when I ran over and snatched it right out of her hands! Luckily I missed her fingers, and the girl surprisingly found it funny.

So if you're going to pack a snowball, you better do it quick—or it might not be just the snowball you lose.

What can I say? I'm cray cray for snowballs.

However, it's gotten to the point where Mum and Dad have to restrain me as we pass the neighbors' houses, because I'll even try to destroy all the snowmen and snow forts in the yards!

Eventually all the kids in my neighborhood started thinking there's some evil bully going around destroying all their work.

Little do they know it's just a little ol' wiener dog who does it for kicks.

 Keep snowballin',
Crusoe

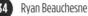

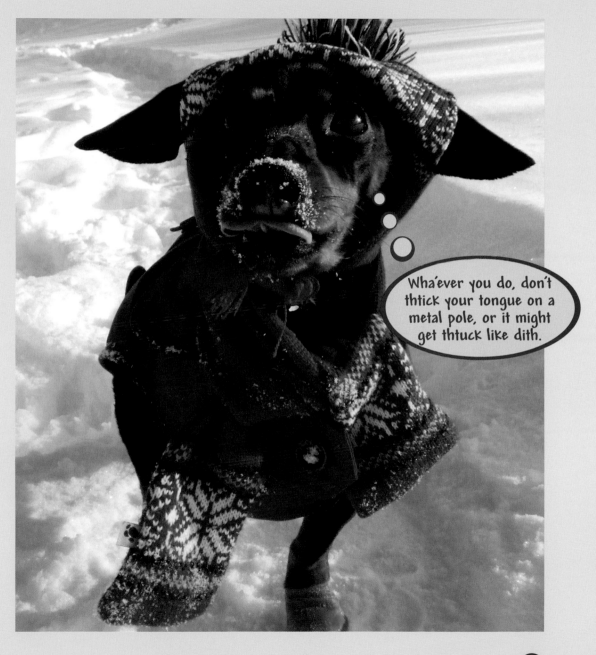

 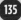

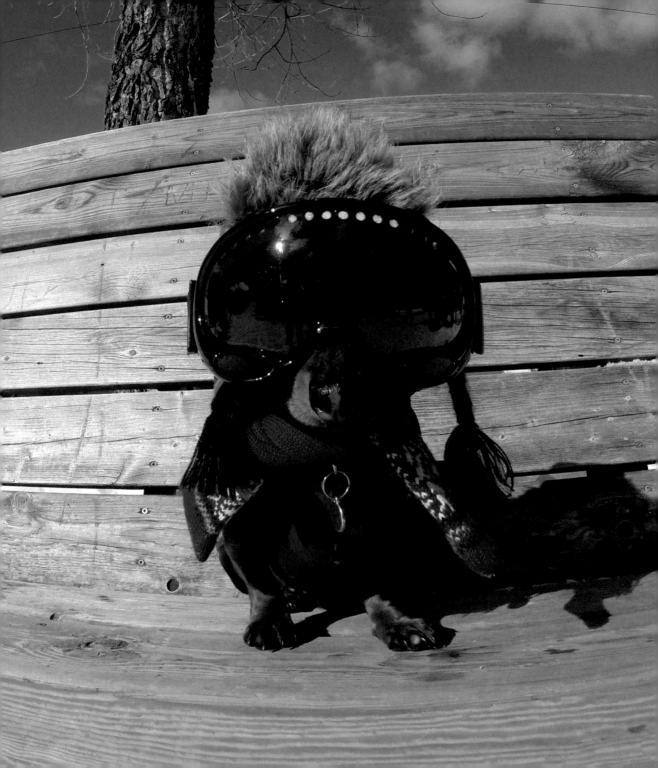

Dog Gone Skiing

Recently I tried downhill skiing for the first time in my life. As usual, I (as well as Mum and Dad) underestimated my uncanny ability to pick up new things quickly and do them exceptionally well.

On the left I am one "cool" dog ready to hit the slopes!

So how good was I? Well let's just say I'm already considering an Olympic career. Although I'm not sure which sports category I would fall into. . . .

I don't know if this contraption Dad built for me would be considered skiing, bobsledding, luge, or what!?

Perhaps they'll have to create a sport just for me.

And so it was off to the chairlift!

Mum had me in a near-death grip the whole ride. I understand I'm her baby, but heck, give a guy a little room to breathe, would ya!

I was getting excited just from watching the other skiers come down the hill below us.

We got off the chair and Mum and Dad helped seat me into my little ski/bobsled contraption.

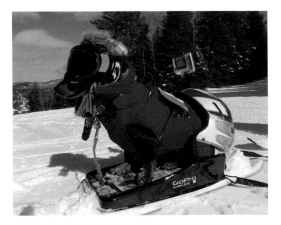

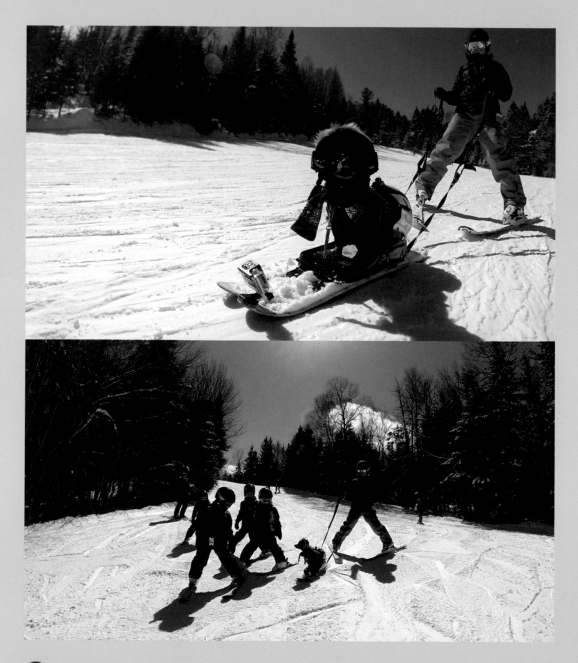

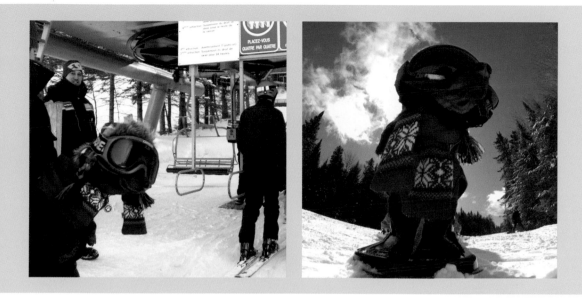

I was ready to ski some powder! Or as us real skiers call it, "shred some pow!"

So with Mum holding the reins behind me, we cast off down the mountain. Unfortunately one thing Dad forgot to install on this ski-sled were some breaks—so I have to rely on Mum to control my speed.

"Faster Mum, faster!"

She never listens to me. . . .

But before long—and as I should have suspected—people were flocking to meet and greet what is likely to be the only skiing dachshund in the world.

Once they got their fill of my awesomeness, I was finally free to cruise down the mountain—to experience that cool mountain air rushing over my face and to take in the majestic beauty all around.

And so my decision on skiing—and the part Mum and Dad found funniest about the day—was that I loved it!

It's true!

The whole time I never complained. In fact, quite the opposite. As Mum said, I "seemed excited about it" and enjoyed the scenic landscapes, the crisp mountain air, and watching all the people zoom by!

I guess that's just further confirmation that I was born to do many things.

Keep skiin',
Crusoe

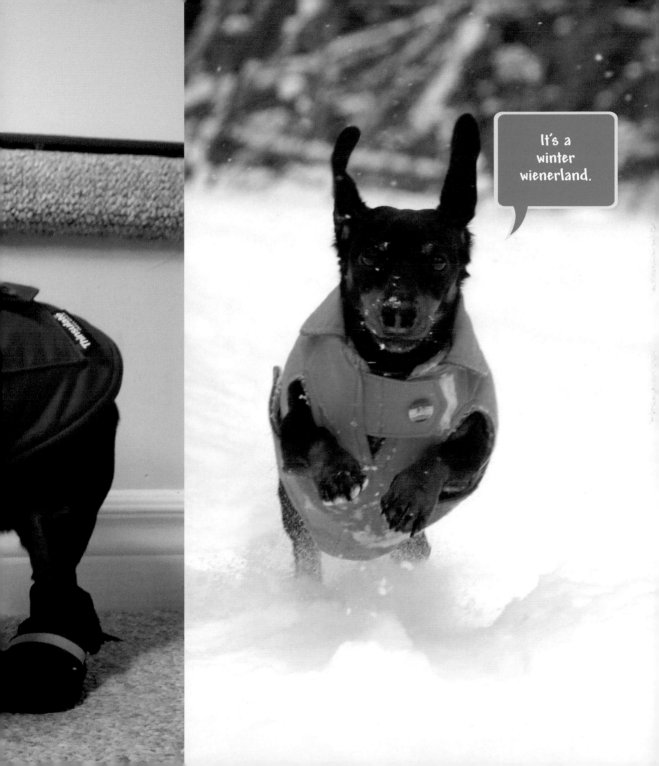

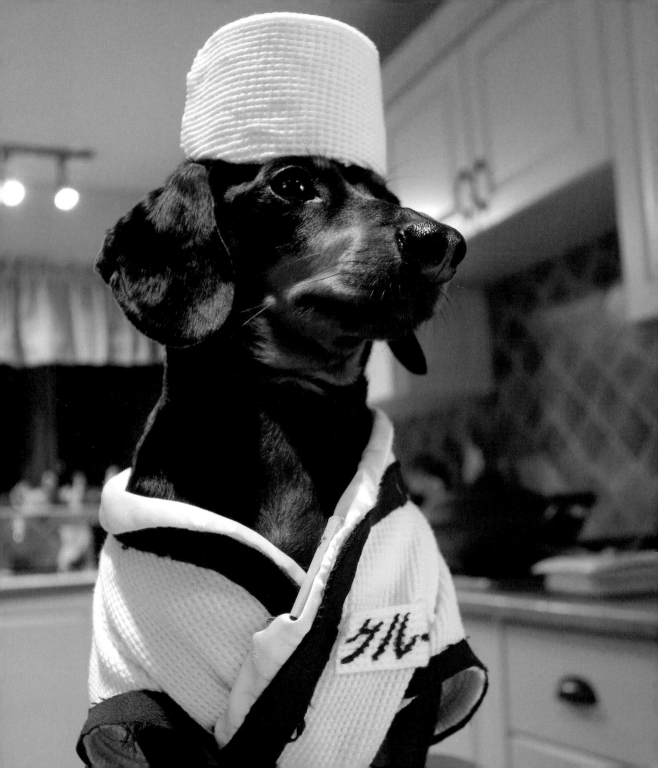

Sushi Night

You may already know me as Chef Crusoe, but now you may also refer to me as Sushi Chef Crusoe, or if you're more traditional, Itamae Crusoe. As you know, fishing is my all-time favorite activity, plus I love the taste of fish, so becoming an overnight sensation as a Sushi Chef was easier than you might think.

For this sushi meal, I am at a friend's house so will be using their kitchen, and will have my friend Charles (one of my fishing buddies) as my sous chef.

Sushi is one of the few types of food I know where you can use virtually any ingredients you like! I recommend salmon (my favorite), shrimp (meh), and some large o-rings (don't know how those got in there).

The important part of being a chef—and something I often forget—is that we're cooking for other people, not just ourselves, and therefore need to consider what they might like. In that regard, we'll also (unfortunately) need to include some fruits and vegetables.

So I would recommend some fresh cucumber (meh, bland), asparagus (yuck—

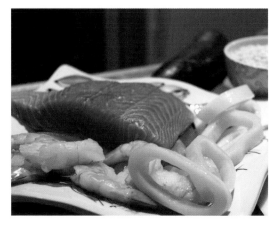

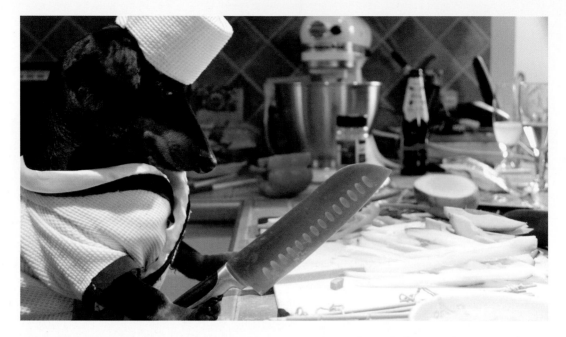

tastes like tightly packed grass), green or red pepper (not bad), and some fruits like mango (pretty good).

So, ready to begin?

Good.

The first step is to thinly slice all the vegetables, fruits, and fish into little strips. Being the smart one around here and always looking to save time (since my time is so valuable), I suggested we just get Mum's paper shredder and put everything through that.

Mum admitted it was a great idea, but that a strong part of being a sushi chef is "putting on a show" of preparing the sushi.

I agreed, and thus took out my large chef's knife to do some slicin'.

As you can see, I'm very concentrated with a knife. (Mainly because I don't have thumbs so I need to be extra careful.)

Meanwhile, I had my sous chef Charles deep-fry the shrimp and o-rings.

Now we can put together our different rolls, such as this one of fried shrimp and asparagus.

There is a special technique to rolling them up, so I start by doing one as an example first.

Then I have my sous chef do the rest while I supervise, and criticize.

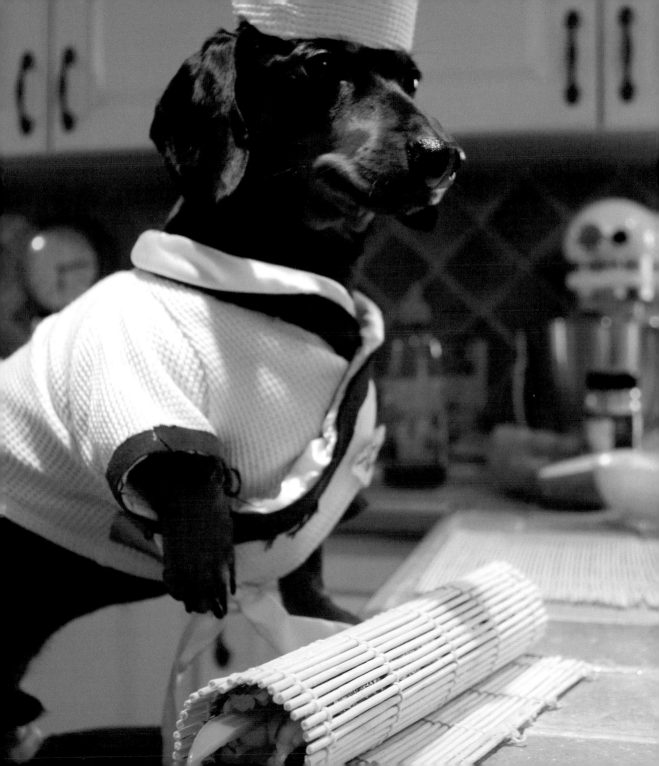

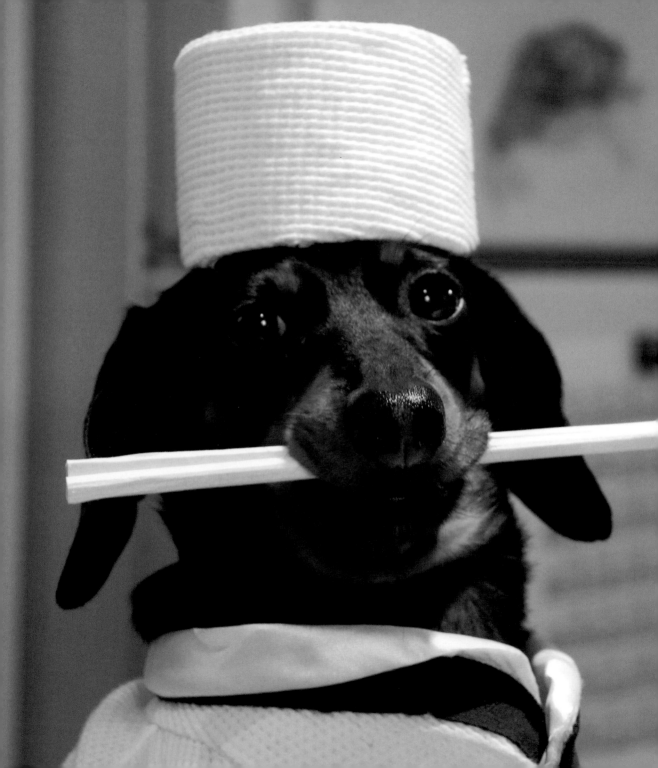

"Charles! That one doesn't have enough salmon. Start over."

"What kind of sloppy mess is that? This is sushi, not a street-side taco! Start over."

"That looks like soggy dog food rolled up in a dirty carpet! Start over."

"You're not rolling cheap cigars here, show me some finesse! Start over."

"The thickness of that roll is totally uneven. Do you need a ruler? Start over."

"This one smells like cabbage. I don't remember including cabbage as an ingredient. Start over."

"I see you trying to sneak in those extra vegetables! Start over."

Finally he came to me with a roll which I was able to approve.

And soon one approved roll turned into three, and we were on a roll.

After they were all approved, it was time to chop them into the little bite-size sushi rolls we all know.

For the final presentation, I laid them out myself. Another tip to being a chef is

to always make the final touch, and serve the food. That way you get all the credit.

And now it's time to eat!

Bring out the chopsticks! Although I'm not sure why they're called "chop" sticks. No one's going to do any chopping with these. . . .

That was a test, by the way. The traditional way to eat sushi is with your fingers, not chopsticks!

However, I have to break tradition regardless since I'll be eating them directly off my plate.

"Now, would someone please pass me the salmon rolls. . . ."

Bon appétit! Oh wait, that's French. . . . Whatever, enjoy!

Keep choppin',
Crusoe

Dr. Crusoe:
Mum and Dad Get Sick

The start of winter is generally the cold and flu season, so it was no surprise when Mum and Dad fell ill.

This is what sparked another one of my many great ideas.

I decided I would buckle down and study up over the weekend on all the medical material I could find online, thus self-certifying myself as a doctor. I then opened an in-home medical practice where I am now offering medical services to all the sexy ladies of my neighborhood—but also Mum and Dad when they need it.

But I couldn't just "diagnose" Mum without first receiving her at a proper doctor's office (hey, it's all about "image,"

right?). Actually it was a veterinary office, which was the only one I could find available for rent.

(You have to admire the irony—a dog doctor receiving a human patient at a vet clinic.)

"So what ails you, ma'am?"

Mum then proceeded to explain how, recently, she had been experiencing symptoms characteristic of a "cold."

However, my suspicions were slightly different. I thought there might be a more sinister illness at work here. . . .

I couldn't be sure, though, so I told her we'd have to take this to the operatory (our living room) for further analysis.

I made sure to wear my full scrubs. I've heard dogs can catch some human colds, so I didn't want to take any chances of infection.

The first thing I did was take her temperature the old-fashioned way.

She was indeed burning up.

I needed to know just how severe it was, though. So I ran upstairs and grabbed the thermometer and brought it back to her.

"Stick this up your butt," I told her.

She then proceeded to inform me of some very disturbing and maddening news, which was that humans can check their temperature just under their

tongues, while us dogs have to get it up the wazoo. This is exactly the sort of thing that makes me prefer human doctors over those quack vets.

So anyway, I'll see to that matter another time. In the meantime, Mum took her temperature for me.

Not good indeed.

I then asked her to describe her other symptoms while I sat bedside so I could provide my professional diagnosis.

I'm not sure what the heck she found to be so funny. . . . I had to tell her to wipe that smirk off her face. This is a doctor's office, not a comedy show.

These were her symptoms:

- Sneezing

- Fever

- Coughing

- Sore throat

- Headache

- Low energy

- Fantasizing about running away to a farm and raising wiener dogs

Interesting. So what did I do next?

Well, I went to my office and just Googled the dang answer like every other doctor.

Except Google didn't have the answer I was looking for to confirm my suspicions. So I had to come up with my own diagnosis—which is that she has dachshuenza—a rare condition I just made up which is essentially the flu, for someone who's obsessed with dachshunds.

By this time Dad had caught dachshuenza, too. And let me tell you, Dad was a much bigger baby about it than Mum was.

So to shut him up, I figured a nice homemade chicken noodle soup might do them both some good.

Of course I had to do some taste testing to make sure it wasn't too hot.

My next job as dogtor was to prescribe

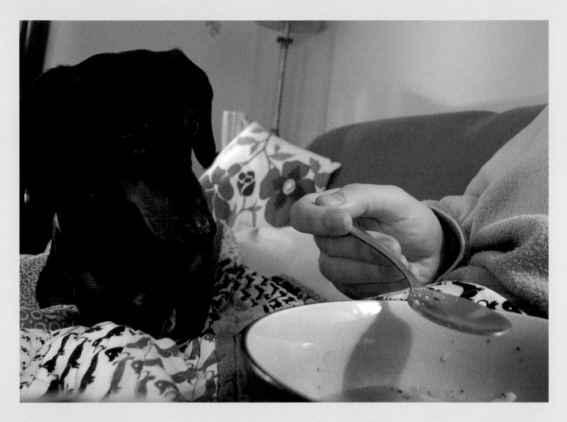

them a strict plan of medication to make them feel better.

Here was my explanation: "You are to take two of these red cold and flu pills every three hours—downed with a shot of whiskey. Then there's some Hall's lozenges for your throat and two pieces of gum for afterward to remove the alcohol breath. I'm not sure how the cookie got in there, but feel free to kick that back my way."

All in all, Mum and Dad were appreciative of my efforts, and I'm sure they'll be feeling better in no time.

 Keep practicin',
Crusoe

P.S. Dr. Crusoe claims no liability for any misdiagnosis, irrelevant prescriptions, or overall malpractice.

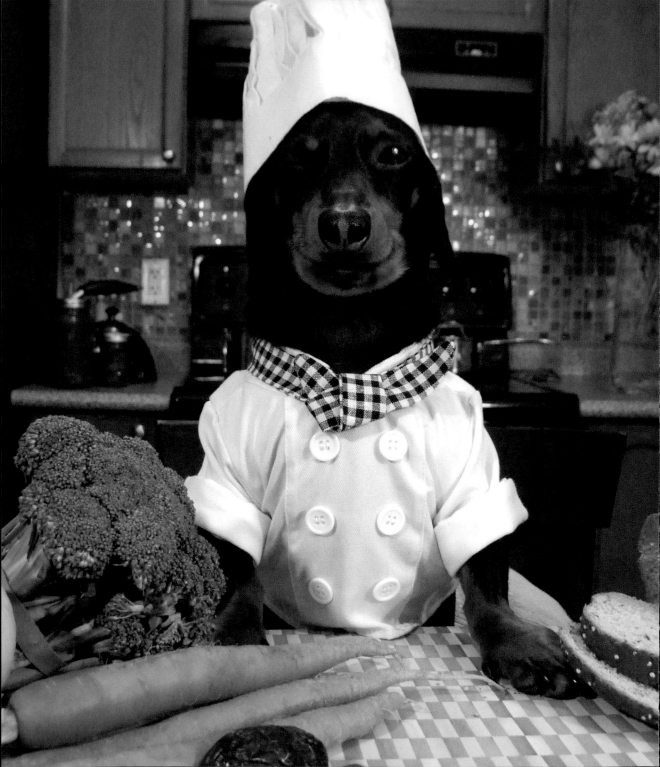

Chef Crusoe

Carrot Cupcakes

In this episode of Cooking with Crusoe we'll be making carrot cupcakes, since I love carrots, and cupcakes are one of the most popular Valentine's Day treats! And if, last-minute, I have any babes over for Valentine's Day I need to at least look like I was expecting them!

Wink

But seriously, what girl can resist a dog who knows his way around the kitchen?

So on to the recipe! Please keep in mind that although I am a self-proclaimed professional chef (among other things), I don't always know what I'm talking about. Please take whatever I say with a grain of salt (pun intended).

INGREDIENTS

A bit more than a grain of salt

Lots of carrots, as some may get eaten in the process

A couple eggs (which taste better cooked, by the way)

White stuff

Brown stuff

Other stuff

A touch of doxie paw

I assume you'll just Google whatever parts I leave out.

Step 1: Prepare the Carrots!

The first step is preparing the carrots. You'll
want to grate them so you have a good cup's
worth. If you're anything like me, you'll likely
feel an overwhelming temptation to pose like
Bugs Bunny first, though.

I've always wanted to do that.

(This is why you'll need extra carrots.)

Step 2: Prepare the Rest

After you prepare the carrots, you need to
prepare the rest of the stuff in your mixer
bowl, including the white stuff, the brown
stuff, and the other stuff.

Step 3: Put It in the Muffin Tray

Once you mix the batter, you can spoon it into the muffin tray. This one was a bit tricky for me to do myself, so I had Mum do it for me while I supervised.

Step 4: Bake for 20 Minutes

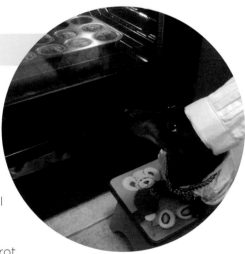

The next step is to bake them for about 20 minutes. Us dogs have a pretty good internal clock, so I said to heck with the timer.

Like many other things in this house (which are under ongoing discussion), the oven wasn't made to be at dachshund eye level, so I had to use this dinky stool to see in.

Oh well, at least I could enjoy those sweet carrot cupcake aromas and be nice and warm while sitting there.

Step 5: Add Icing and Serve

The last step is to add the cream cheese icing and serve the cupcakes. Supposedly it's rude to eat one before you serve others, but hey, carrots and cheese—how could I resist?

I'm sure no one will notice that one has been nibbled on.

I just hope I don't eat them all before I've had a chance to serve them to some nice ladies on Valentine's Day. Speaking of that, I should probably hide them from Dad, too.

 Keep bakin',
Crusoe

According to my calculations . . . We can afford my squeaky balls!

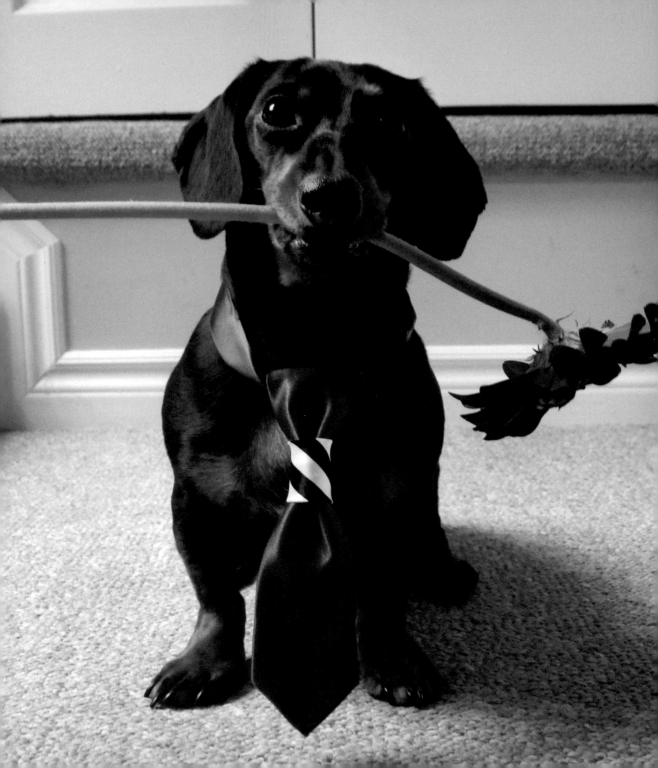

Date Night, Bachelor Edition

I recently found myself caught between two lovely ladies. I liked both of them, and they both liked me. And as content as I was keeping it that way, they both insisted it was time for me to decide between them.

However, the choice wasn't so obvious, so the best idea I had was to invite them over for a romantic evening to finally decide which of them I would choose.

So to present you my candidates, here we have Gogo on the left and Zoey on the right.

Quite the cuties, aren't they?

When they first arrived I greeted them at the door to explain how the evening would work.

"Hello, ladies," I said. "Tonight, as you know, is a very special night. In this ABC's *The Bachelor*-style evening, we will be partaking in various activities together to help me decide which of you I'm more in love with. I will be awarding points throughout the night, and at the end, I will present this flower to the woman of my choosing."

So with that, I invited them in for the first activity—which was my dating interview.

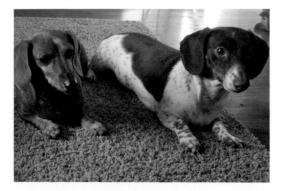

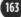

Crusoe: So, ladies, I have a few questions for each of you. First one: If we were washed away on a desert island together, what would be the first thing you would do?

Gogo: I'd look for a nice warm patch of sand to snuggle up next to you on!

Crusoe: I can dig that!

Five points for Gogo. Ten points to myself for being so desirable.

Zoey: I'd go find us both some dinner!

Crusoe: Great! I like a girl who knows how to survive.

Five points to Zoey as well!

Crusoe: Next question: Do you prefer chunky or smooth?

Zoey: Definitely chunky.

Gogo: I prefer a smooth and muscular physique, like yours, Crusoe!

Zoey: I thought we were talking about peanut butter?

Three points to Gogo, two to Zoey, and seven to me for so graciously receiving that compliment.

Crusoe: Now, the next question: If you could take me anywhere, where would it be?

Gogo: I would take you back to that desert island so we could be alone together, forever and ever.

Whoa! I had to look at her quizzically to see if she was indeed serious.

And she was . . . !

Minus three points. I'm not ready for

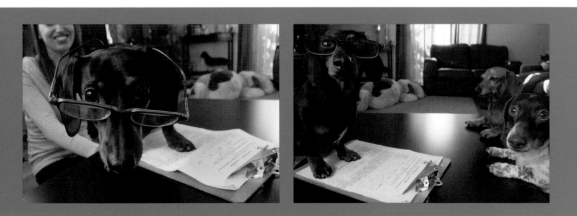

 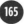

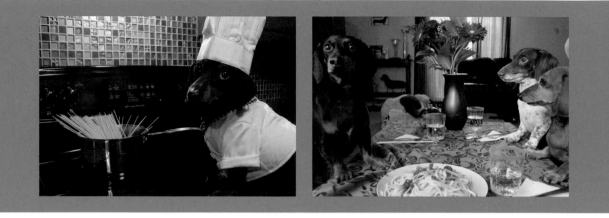

that sort of commitment yet. And minus two points from myself for being too desirable.

Crusoe: Zoey, where would you take me?

Zoey: I would take you to the kitchen so you could cook us dinner already.

Whoa again! A feisty one—not to mention hungry.

Minus two points for not answering the question properly. Three points to myself for her looking forward to my cooking so much. . . .

Crusoe: We'll get to that soon, Zoey. Just a couple more questions. We'll start with you this time. What is your favorite thing in the world? Besides food!"

She had to think long and hard about that one.

So long in fact that Gogo even started to fall asleep!

When you got one girl confused and one falling asleep, you know it's time to move on.

So with that I headed on over to the kitchen to switch into my Chef Crusoe uniform and prepare the spaghetti.

Of course, I kept looking back to make sure they were watching how good of a chef I am. When I saw Zoey intensely

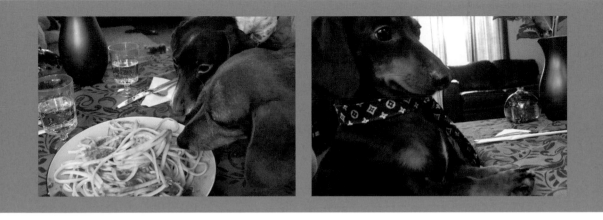

watching me, I awarded her five points, and of course five to myself.

My goal at dinner was to observe the ladies and how they carried themselves—you know, their manners, class, etiquette, conversations, style, etc.

However, right away, I noticed Zoey was much more interested in the spaghetti than me. Minus three points.

On the other hand, Gogo was quite intrigued by my dialog on my recent accomplishment as a successful first-time skier. Ten points to me for being so interesting.

Oh, and five points for her.

Having done the majority of the talking so far, I asked them to tell me a little bit more about themselves. . . .

But, evidently, they were a little preoccupied with the pasta.

However, once Zoey downed her mouthful, she likewise had a mouthful to say:

"Well, yesterday, my mom bought me this pretty pink jacket. It's really cute; you should see it. I tried it on in front of the mirror but it seems a little snug, and it's only a size small. What do you think; do you think a small would be snug on me? Don't answer that. Anyway, I'm going to try wearing it around the house first to see. . . ."

. . . and she trailed on from there.

I tried to maintain a look of interest,

but man-oh-man was that a snooze fest! Minus three points for her, and plus ten points to me for getting through that without keeling over in boredom.

That gave me a good-enough reason to serve dessert.

I thought it was sweet how Zoey offered to share a dessert with me. Five points.

But I see now how that turned out. Never trust a woman when she says she wants to "share a dessert."

Minus five points. And, meanwhile, Gogo thought it appropriate to lie on the table. Minus five points.

So anyway, at this point I feel like I've gotten to know them both very well— perhaps even too well already. I've also lost track of the points, but I'm pretty sure I won. (However, Mum later informed me that I'm not supposed to include myself in the point system.)

Anyway, I thought Zoey was quite a cutie the whole night, so I decided to offer her the flower.

She smelled it, realized it was inedible, and shockingly lost interest.

I couldn't believe it!

So, I gave it to Gogo, and she loved it!

However, I told the girls we may have to do a redo date, because according to my point system I should be dating myself anyway.

Yet regardless of who won the flower or who won the points, Gogo and Zoey will always be two of my best lady friends, and that's something I'll always cherish.

Keep datin',
Crusoe

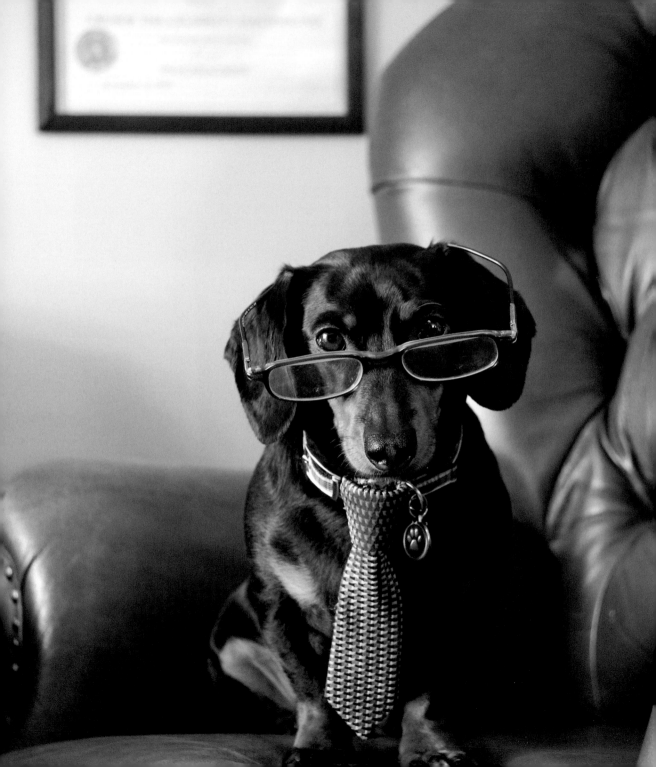

Psychiatrist Crusoe

Since becoming a certified psychiatrist canine just last week, I've begun taking more notice of Mum's mood swings and her complaints about Dad. So after pressuring her to book a session with me, she finally agreed.

And thus, this was my first real session as Crusoe the Psychiatrist.

Mum has a habit of not taking me seriously enough sometimes, so I made sure to point out my degree to her on the wall.

"So tell me what's been bothering you?" I asked. "Is it the fact I'm the best-looking one in the house? I understand how that could be hard for a woman. . . ."

"Uh no, not really."

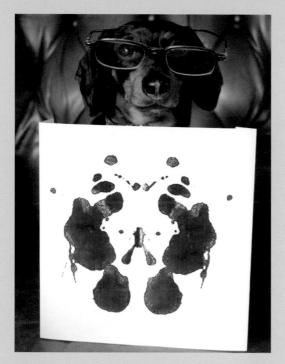

"Is it that you wish you could see to my demands faster, but just can't keep up?"

"Don't think so," Mum said.

"Is it that our vacations are planned around me, where I'm able to fly to, and what attractions I'm allowed to visit?"

"Actually, yes, that's part of it."

"Is it that Dad only takes pictures of me nowadays?"

"That's part of it as well."

I could tell I was on a roll, so I continued. "Is it that Dad plays ball with me more than you?"

"Well, yes—but not that I want to play ball."

Why wouldn't she? I wondered.

"The main reason is I feel your Dad just isn't spending enough time with me," she said. "Plus, he needs to help out around the house more and be more romantic sometimes."

"That's interesting, because I find Dad is very helpful in setting up my photo shoots. He also taught me everything I know about being romantic! He's probably the best womanizer I know."

"Well, I don't think you've met enough male role models, then. . . ." Mum said with a roll of her eyes.

I pondered for a moment. "So are you saying that my time with Dad competes with your time with Dad?"

"That's it!" Mum exclaimed.

"I see. Well, it seems to me you're trying to make this all about yourself."

It was a good thing I didn't see her eyes roll a second time.

"However, I'd now like to move on to a special test. I'd like you to tell me what you see here."

Mum thought for a moment. "Umm, I see an old man with a moustache."

"Wrong. It's obviously a monkey on a unicycle wearing a top hat."

"I don't think that's how these tests are supposed to work, Crusoe. . . ." Mum said.

I ignored her and moved on to my next exercise. "Okay, I'd like you to take these two squeaky duckies and act out some conversations between you and Dad—you know, as if they're puppets."

So Mum started moving the duckies around, giving voices to them as if they were her and Dad.

My exercise backfired when I realized I hadn't heard a word of what Mum was saying and instead had found myself totally zoned in on the duckies and the fact they were being tantalizingly waved around, but not squeaked.

"No, no, no—you're doing it all wrong!" I exclaimed. "Here, let me show you."

And so I took the rubber ducky from her and started rampantly squeaking it.

"You see," I said. "That's how you squeak it."

"Crusoe," Mum said, "you're a bit obsessed, are you not?"

That got me thinking. I am obsessed with squeaking. So much so I decided I should tell Mum all about it.

". . . And so you see, Mum, although

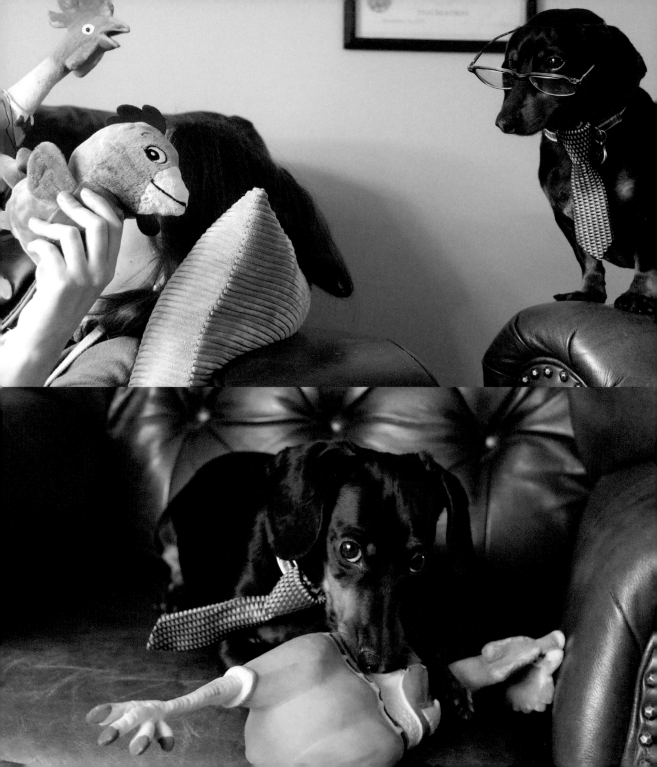

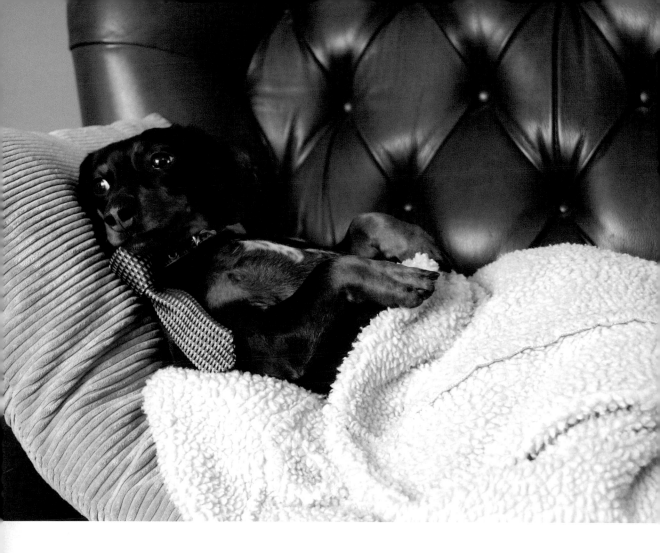

on the surface I'm a very happy-go-lucky dog, deep down I have an unhealthy and troubled addiction to squeaking. . . ."

"Mum?"

"Mum, are you listening?"

Can you believe it?! While I was spewing out my cauldron of heartfelt thoughts that had been boiling up over the years, she had left to go put away my toys!

I have a feeling we're going to need many more sessions. . . .

 Keep listenin',
Crusoe

Well, I've double-checked the list. And everything I asked for is on there, so I should be good to go.

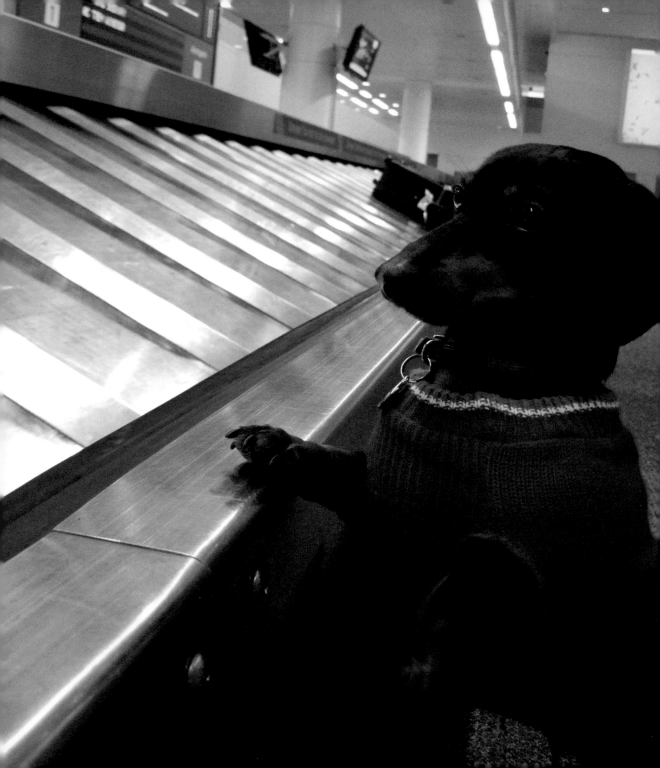

Christmas Break

Every Christmas break my brother Oakley and I get together to enjoy the holidays. It usually starts off by me hopping on a plane in one of my Christmas sweaters. I've been asking Mum and Dad over and over to get me a private jet (that's on my Christmas list) so that I don't have to sit around like one of these "commoners."

And as if that isn't bad enough, I even have to wait around for my own luggage!

But now that I have a book deal, I expect I'll have people to do that for me.

Anyway, it's always an adventure when Oakley and I are together, and most of the time we'd be out playing in the snow, but occasionally the weather can be very cold and inhospitable to little wiener dogs (even despite how acclimatized I am to the snow).

So we have to find other ways to keep ourselves occupied, which most of the time includes a nice long game of chess!

I have to give Oakley credit, he made a superb effort. But as the game approached the end, I couldn't help but display my I-know-I'm-going-to-win look. I just couldn't help it!

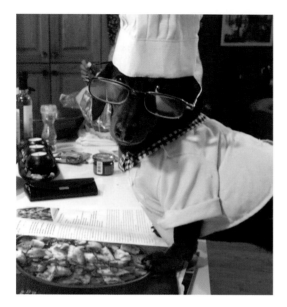

When the big day finally arrives, it's up to Chef Crusoe and his sous chef (Mrs. Claus, aka Oakley) to help prepare the Christmas dinner!

Although, I must say I don't find Jamie Oliver's recipes to be all that amazing. They seem to be extremely lacking in their use of butter, fat, meat, cheese, and bacon. But then again, most recipes are. . . .

In most cases I would have taken several liberties with this recipe, yet since I was cooking for humans as well, I had to follow it to the letter.

So anyway, I told Oakley to get started chopping the onions.

I was a little nervous to see him swing-ing that knife around, and I had to tell him multiple times, "Oakley, it's a cutting knife, not a hammer! Be a bit gentler, would you?"

I guess I can't really blame him since he hasn't gone through hours of rigorous on-line culinary school like I have.

Meanwhile, I peeled and sautéed the carrots, which were virtually perfect in their preparation.

Oakley then wrapped up the potatoes to put them in the oven. I was impressed to see he was wearing his oven mitts with-out me having to tell him to!

After that, I combined all the ingre-dients Oakley prepared into the stupid

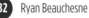

I pretty much enjoy any sport that involves a ball being thrown around. And I always root for the winning team, because it's much more fun that way!

stuffing. What is the point of this boring mishmash of bread and vegetables anyway?

I consider it a waste of my refined culinary skills—but don't tell Mr. Oliver that (he has a Wiener schnitzel recipe that scares me a little).

And when it finally came time to pull the turkey out of the oven, I couldn't even look at it squarely without feeling an overwhelming temptation to lunge at it and devour it.

But once we were at the table ready to eat, I didn't hold back at all and was continuously demanding delicious morsels of turkey! (I passed on the stuffing, though.)

Then finally, the moment I'd been waiting for—Christmas morning!

But it didn't come without a restless night's sleep beforehand. I didn't like the idea of some stranger slinking down our chimney in the middle of the night. . . . After he empties his big bag of gifts he could easily toss a few other things in there on his way out.

So I had to stand guard as BATDOG by the chimney.

I didn't even leave cookies or milk for the guy because a) I want him in and out as soon as possible (no need to distract him into staying longer), and b) I want to make sure he can still fit back out our

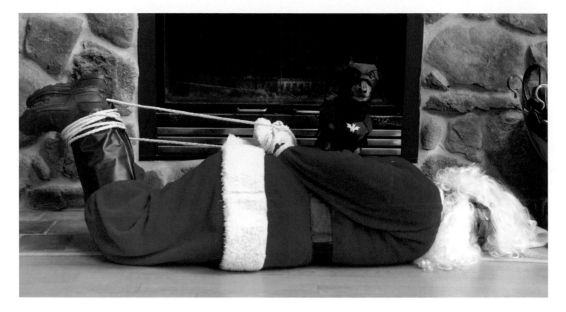

chimney. From the pictures I've seen, this guy needs to cut back on the beer and brats anyway.

My suspicions of him were later justified when, after he managed to sneak past my guard, I caught him trying to get jiggy with Mum.

So obviously, I didn't stand for that.

I decided to make a trade with him, though—he left us the presents as normal, and I let him go.

(I didn't tell anyone else about that little situation.)

So anyway, the first thing I did in the morning was check my stocking, and I was admittedly a bit disappointed. I had spe-cifically asked for bikini babes as stocking stuffers, and I didn't even get one!

What does a guy have to do to get a couple chicks for Christmas?

Anyway, one thing you need to know about me is that I LOVE opening presents. I will open any and all presents under the tree if left unattended (I can't help myself).

In fact, just before Christmas I found Mum's stash of presents for the family in her closet. I opened every single one of them. She wasn't at all as understanding as I thought she should have been. . . .

It's because my first thought of a given gift is that it's most likely for me (which I

think you can agree, is a quite reasonable assumption). However, the only way I can truly find out is by opening it.

Heck, even when someone else has a present in their lap I still think it might be for me!

So I'm definitely feeling it's about time when a present finally comes along that's actually addressed to me!

So let's see what I got. . . .

Here's a gift I received from Mum— wiener dog bedsheets!

"Oh . . . how lovely."

I'm pretty sure she mostly bought those for herself.

I also got this nice scarf, which Oakley was clearly a little jealous of (see above).

Yet as great as the gifts are, my favorite part is always just opening the presents themselves!

But, ultimately, as long as I get a few new squeaky toys and enjoy some quality time with my bro and the family, that's all that really matters.

Oh, and turkey. Must have turkey.

Merry Christmas, everyone!

 Keep unwrappin',
Crusoe

SPRING

Oakley's Vacation Visit

"Photo-bummed" by my brother Oakley.

Ahh, spring is here! And usually every spring, Oakley and his family come to spend a couple of weeks at my chalet as a sort of vacation. Since we don't see each other very often, we make sure it's one heck of an adventure every time!

Our families love to take us on a beautiful kayak ride through the nearby national park.

As the leader of the expedition, I'm at the front of the kayak—and flexing, of course.

However, the entire day is like one big game of musical chairs kayaks—where Oakley and I are constantly swapping boats and trying to get a spot on the kayak that's the farthest ahead.

Oakley takes the game pretty seriously,

often hanging precariously over the nose of the kayak.

You'll also notice that he's all wet in most photos, which is because every once in a while his eagerness comes at the expense of his balance, and he falls in.

I, on the other hand, have very seasoned sea legs.

But despite our trivial games with brotherly competitiveness, we can both appreciate the beauty all around us.

Our seafaring adventures don't stop at kayaking, though! Before long we were back out on the open water of the lake.

From life jacket to board shorts!

So with our ears in the wind and noses to the sea, we were constantly on the lookout for the beach and any babes that may be floundering and in need of rescuing.

We didn't find any of the latter, but we *did* eventually find the beach. Good enough for now!

Back at the house, Oakley and I were running through a few of our fire drills. I've never told anyone before, but my chalet actually had a small electrical fire in the roof one time while I was home with Mum and Dad.

I was the first to smell the smoke, and I warned Mum and Dad. Luckily, the firefighters arrived in time to put it out before too much damage occurred.

After that I became a full-time fire-

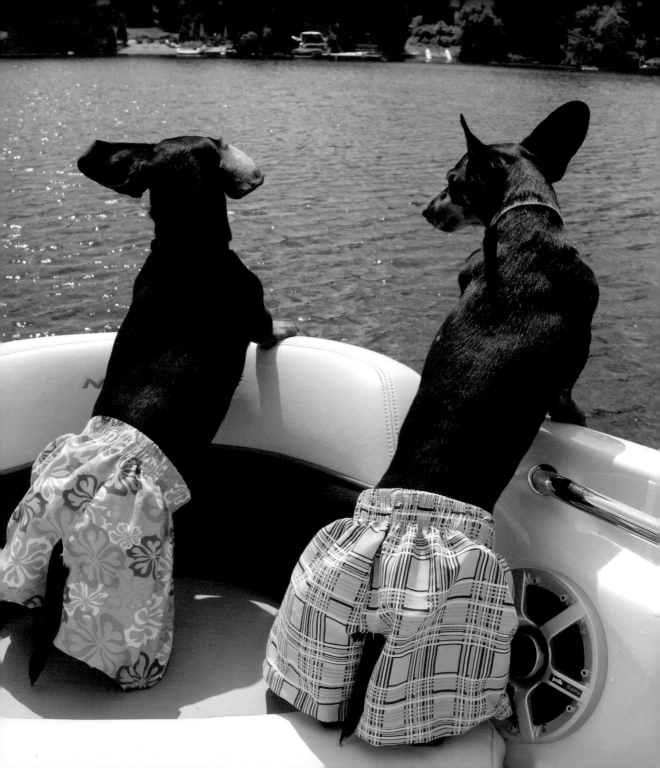

fighter at my local fire station, determined to never let my family be caught so off-guard again. Safety is very important!

So since then I've been fire-ready! But now I wanted to introduce Oakley to the importance of practicing fire drills around the house.

And thus, Oakley became the fire truck.

Now we may be experts at putting out fires, but we're not fans of being wet—that's for sure! Because a wet wiener = a grumpy wiener.

Here's Oakley and me (I'm on the left) ready—albeit unenthused—for our walk. . . .

 Keep drillin',
Crusoe

Spa

Spring is the time for rejuvenation.

That's why I like to kick off the season with a little yogurt facial. It does wonders for the pores, plus it's delicious.

Heck, I could barely keep my tongue inside my mouth!

Dad gives me a mandatory massage just about every night, but I still like to go to a real spa once in a while. Actually, the real reason is that he's just not up to my standards.

Plus he always saves half the yogurt for himself, which is unacceptable.

 Keep relaxin',
Crusoe

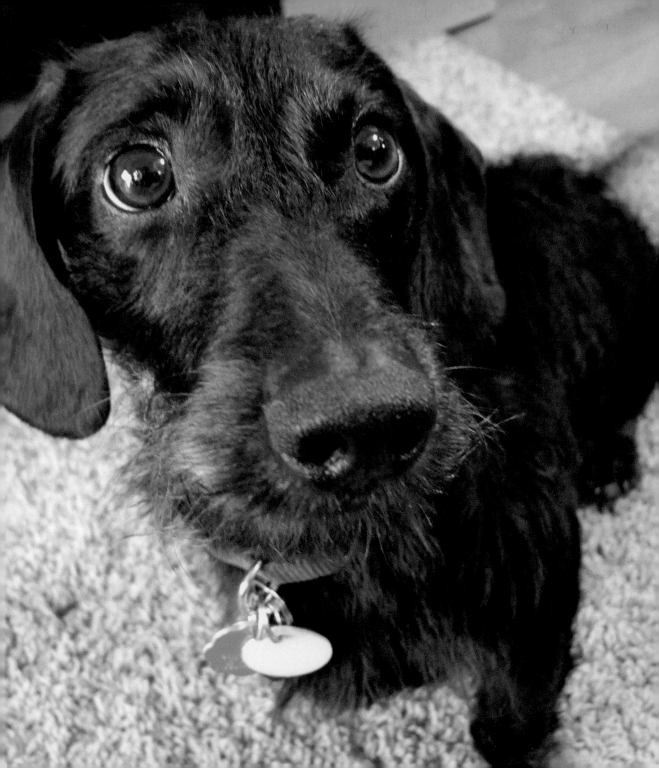

The Truth About Wire-Haired Dachshunds

I've had trust issues with wire-haired dachshunds for quite a while now. It's not that I dislike them—I just don't trust 'em.

Allow me to explain. It all started almost two years ago at a wiener dog race in Montreal. It was a very important race—in fact it was the qualifying round for the finals.

At the time I could tell the guy beside me was a cheater and a trickster just by looking at him. And as I suspected, the little sneak took off before the clock hit "go," and he was already halfway down the course before I showed him who's boss by zipping by him for the win. "In yo face!"

Since many people have been asking me to put my issue with wire-haired dachshunds to rest, I've now decided to see for myself if I can trust them by inviting one particular wiry fellow over to my home for the day to conduct a series of tests, interviews, and covert monitoring.

So to introduce my guest, on the left is Cooper (formerly Jack)—a mini dachshund who was just recently rescued from a shelter.

I also decided that for the first part of his visit, at least, I would maintain my own disguise as a wire-haired. I figured if he thought I was one of his kind, he might open up and expose something of interest—like a master plan for a PetSmart heist, a steroid smuggling ring, or, heck, even a plan for worldwide wire-haired domination (I know the UK is full of them already).

Before he arrived, I had Mum hide all

our valuables around the house, especially the trophy I won at the race.

I've never really gotten this up close and personal with a wire-haired before, but my disguise gave me confidence.

I'm pretty sure he fell for it.

After introductions and some brief pleasantries, Cooper went straight for my toys. I would have appreciated him asking first, but I understand he might not have all the same high-society manners that I've developed.

And so we formed our acquaintance over a couple of squeakies.

I was a bit perturbed when I saw Cooper relieving some of his sexual tension after being in the joint all that time when he began to hump my big teddy.

I wasn't impressed.

I decided it was a good time to move on to my interview.

We sat opposite each other while I asked questions from my clipboard. He seemed a little distracted at first by the camera, but I assured him he was only being recorded for quality purposes.

Wink

Here's a little on how the interview went:

Crusoe: We'll start with a basic question. What is your name?

Cooper: Jack. Oh wait . . . No, it's Cooper now.

Hm, not the best start. Does he actually not know or is he messing with me?

Crusoe: Where are you from?

Cooper: I was at a shelter in Quebec, but was just rescued and am now with a foster family.

Crusoe: And how did you end up in this shelter?

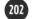

Cooper: My old owners couldn't care for me anymore.

I wondered why, and made a quick note to revisit this point.

Crusoe: Mmm. And have you ever committed a crime?

Cooper: I stole a bit of food once because I was hungry.

I discretely gestured at Dad to go hide my kibbles.

Crusoe: Why did you hump my teddy?

Cooper: Well, I just got neutered a few days ago, so I've been meaning to see if everything still works down there.

Crusoe: I can relate to that— unfortunately. However, next time please reserve this activity for your own teddy. Mine needs to be washed now and I much prefer him not washed.

I continued . . .

Crusoe: Have you ever broken someone's trust, cheated, or disobeyed rules?

Cooper: I did what I had to do while in the joint, but it was my last owners that betrayed MY trust. . . . I've been without a real home for a while now.

I couldn't help but feel compassion for the guy. . . .

Crusoe: And how do you feel about being a wire-haired?

Cooper: Good, I guess, but I find myself questioning why a nice family doesn't come and adopt me. I am well behaved, house-

trained,
just neutered
(as we
discussed),
and would be so
grateful to have
someone to love me
and call their own.

 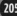

Okay, this interview was starting to get a bit too sappy for me. I needed to lighten the spirits and change it up.

I decided we would play Scrabble. Having set up a series of hidden cameras, my objective was to see if Cooper might be tempted to try a sleight of hand, especially when I offered him one of my toys to keep if he won.

It was a pretty close game at first, but after a while I couldn't help but display my I-know-I'm-going-to-win look, Part 2.

After later reviewing the surveillance tapes, I'd say he kept it pretty clean. I'd be lying if I said I wasn't just a little disappointed in not catching him red-handed trying to take extra letters from the pile.

And before I knew it, it was time for Cooper to go home. We said our good-byes, and I sent him on his way with a few of my toys that he really seemed to like.

I'll admit, I rather enjoyed my day and might even call Cooper a friend. He followed Dad around a lot, too, which tells me he really wishes for his fur-ever home. It makes me appreciate how ever-so-fortunate I've been in my life—to have a loving family and a real home, not to mention I'm a world-famous celebrity who gets tons of chicks. I really hope Cooper finds a similar good fortune soon.*

I would be able to say I wholly trust them now if it wasn't for one little thing that I discovered after Cooper left. Dad brought up my dog bed from the car when he returned, and upon sniffing it I immediately realized that he had pooped on my bed!

Not sure why he did that but anyway, I've learned not to dwell on these things.

In conclusion, I had a good time with Cooper, and I think we can officially say "I trust them," albeit with just a little healthy skepticism.

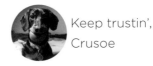 Keep trustin',
Crusoe

*Note: Cooper has since been adopted by a wonderful loving family.

I'm going on vacation to the Bahamas soon! :) Time to practice my snorkeling in the tub!

I recently mastered the art of walking on stilts. The main purpose for which was being able to reach the cheese plate. . . .

I just have to be careful not to drop the cheese, because I haven't figured out how to reach down on these things yet.

My Trip to the Dentist

I may already have an immaculate smile, but even I have to go to the dentist now and then.

However, I've decided that I won't go to the quack *vet* for my dental work and checkups like regular dogs anymore. I find the atmosphere very stressful at the vet, and also very lacking in the comfort and entertainment department for a celebrity. I'd like to watch a little Animal Planet or something while I'm getting my teeth cleaned at least. And I'd much prefer to sit in one of those comfy dental chairs rather than be pinned down to a cold metal table.

So this past week I insisted that Mum and Dad take me to one of your human dentists.

When they called for the appointment, the dental office said they don't usually accept dogs but that they would make an exception for me.

As I expected.

I was quite impressed when I got there. For one thing there wasn't even one fat lazy cat in sight! I never liked those sauntering felines that hang around the vet's office like they own the place. . . . always seeming to mock me somehow.

Anyway, the hygienist led me to the room and had me sit in the big chair. I'll

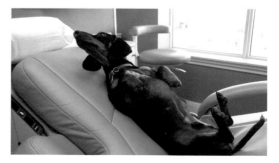

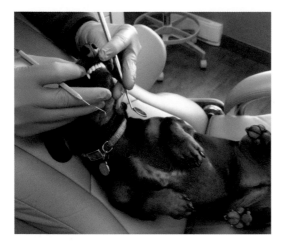

then went so far as to say that I may not be brushing my teeth enough!

I was insulted not by the fact that she thinks my teeth are not clean enough (well, partly that) but mostly because she thinks I brush *my own* teeth! I have people to do that for me, thank you very much!

So that's when I concluded that this lady was just as much a quack as all the vets I know, and that she doesn't know what she's talking about.

Henceforth, I decided to take matters into my own paws, and in doing so told the hygienist I would not be requiring her services any further.

My plan was to do my own dental work just using a mirror (I'm pretty habituated to mirrors), but maybe this was a bit ambitious. So I told Mum to hop up on the chair and let me practice on her before doing anything to myself. She refused at first, but then I threatened to not cuddle with her for a week if she declined. She accepted.

It was nice to be on the other side of the mask for once. I had to revel in the moment for a few seconds . . . while flexing of course. I briefly considered the idea of opening a dental clinic specifically for beautiful ladies.

However, the problem quickly arose

admit, I was a little nervous at first, always glancing back to see what she was doing and what sharp tool she might be pulling out of her drawer.

She first pulled out a little mirror and a sharp pointy stick.

"Oh, a mirror! Great, I haven't had a chance to check out how good I look since I left the house," I said.

She responded rather impudently, saying that the mirror was for her to see inside my mouth. But instead of dwelling on that, I refocused my attention to the TV up above.

That is, until she told me that I had a couple of stains on some of my teeth.

"From what?" I demanded, to which she just said it can sometimes happen, and that it's very hard to remove. She

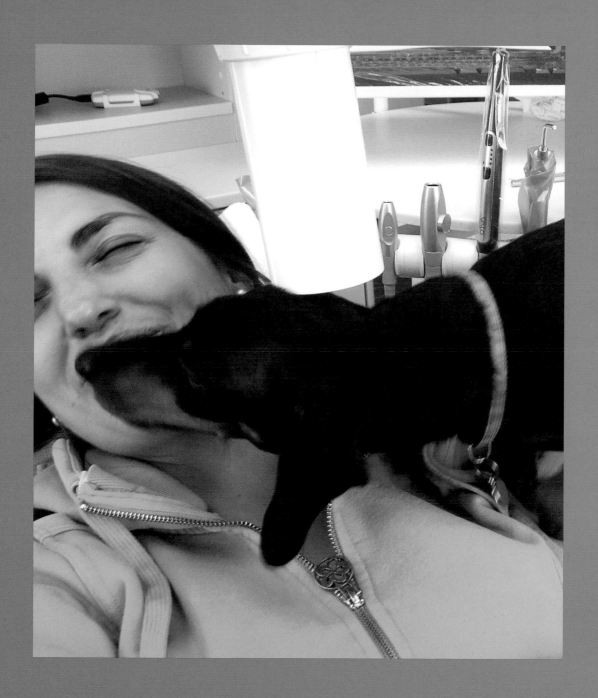

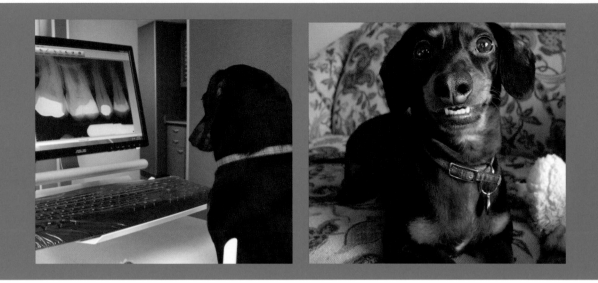

that I couldn't hold on to any of the dang tools.

This was very frustrating, and it didn't help that Mum found this to be funny. So I decided to clean her teeth the only way I knew how! (And to effectively wipe that smirk off her face!) See previous page.

So that worked well, and was much easier than using those dinky little tools. I don't know why more dentists don't use this technique.

But the final test was analyzing Mum's X-ray results.

After careful examination, my professional opinion was that her teeth looked awfully long in this photo, and they should be shortened. I'll be sure to recommend that to the dentist here.

I guess I'm a pretty good dentist after all. I knew it couldn't be that hard, but I still decided I'll practice on Mum a few more times before I try on myself.

And since my visit to the dentist, Dad has been on a strict schedule to brush my teeth every night.

I'd say I have a pretty good smile, don't you?

 Keep brushin',
Crusoe

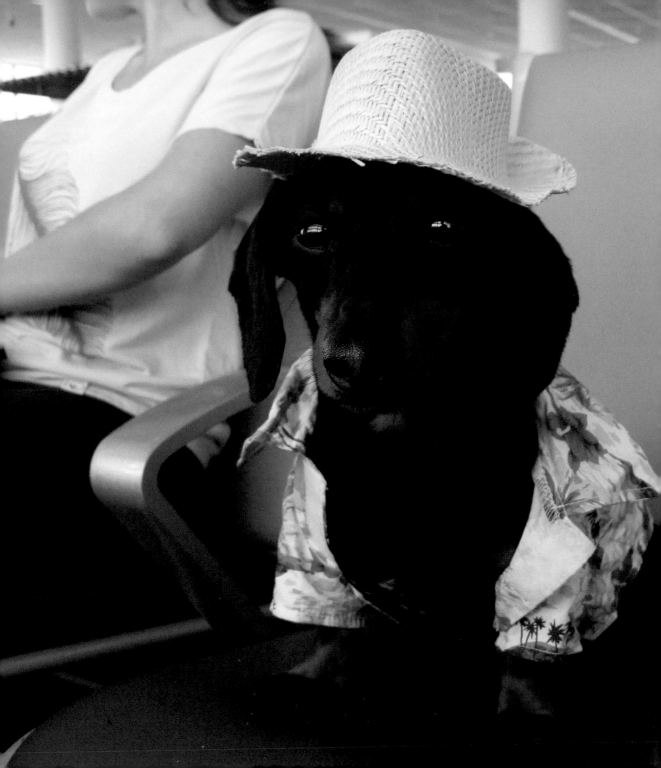

Bahamas Vacation

Finally the type of vacation I had been waiting for, one with private villas, tropical islands, and luxury yachts. Yes, I went to the Bahamas, and what an adventure it was!

I made sure to pack all the essentials, including:

- Plenty of squeaky balls

- My life jacket (Mum said I have to)

- Plenty of other toys

- A set of dumbbell weights—you know, so I can pump some iron before hitting the beach

- My big teddy—though he won't fit in the suitcase so I told Mum to book him a seat on the plane

I think it was pretty clear I was excited for the trip judging by my airport attire. . . . Note my tropical shirt and straw hat.

After being inhumanely stuffed in a carry-on bag and then being squished under the seat for a few hours, we finally arrived in the Bahamas and were aboard our own private yacht before I could complain further.

Our plan was to sail through the Exuma islands and then stop off in Eleuthera for

some relaxing time ashore in a private villa.

It was a beautiful feeling to have the cool sea breeze under my ears, the ocean twinkling like sapphire, aquamarine, and emerald all around, and only a speck of green land off in the distance.

Could it be? Yes, I was sailing. I'm a sailor. I sail.

Mum and Dad made sure to doggie-proof the ship, meaning they lined all the railings with mesh and ensured I wear a life jacket whenever I wasn't under their strict supervision.

But once they gave me the liberties to finally explore my own ship, I took advantage.

The open ocean—as far as the eye could see—was mine to explore and conquer.

Our first "land-ho!" was a little island with some beautiful beaches.

I was a happy pup.

Especially when Dad would whip the squeaky ball down the beach for me to chase! Pure, unobstructed fun!

However, my favorite activity was digging in the sand/burying my squeaky ball/getting excited at the thought I couldn't find it, then digging it up again, only to repeat over and over.

But when you're muzzle-deep in the sand it's hard not to get it all over your face—and also hard not to digest some in the process!

That's right; the next day Mum and Dad realized I had perhaps eaten a bit too much sand when they saw I pooped little logs of 100% pure sand.

Mum was worried, but Dad said it would just "clean the pipes."

But anyway, while on that same beach, this random man seemingly appeared out of nowhere to let us know that we were in fact on a private island. I didn't like him to begin with, but especially not after he told us that.

So I responded, "Yeah, well, you see that island over there," and I pointed to the biggest chunk of land I could see off in the distance. "I own that island. I just

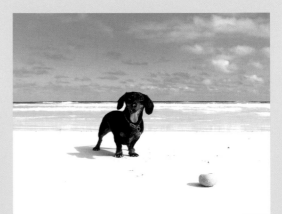

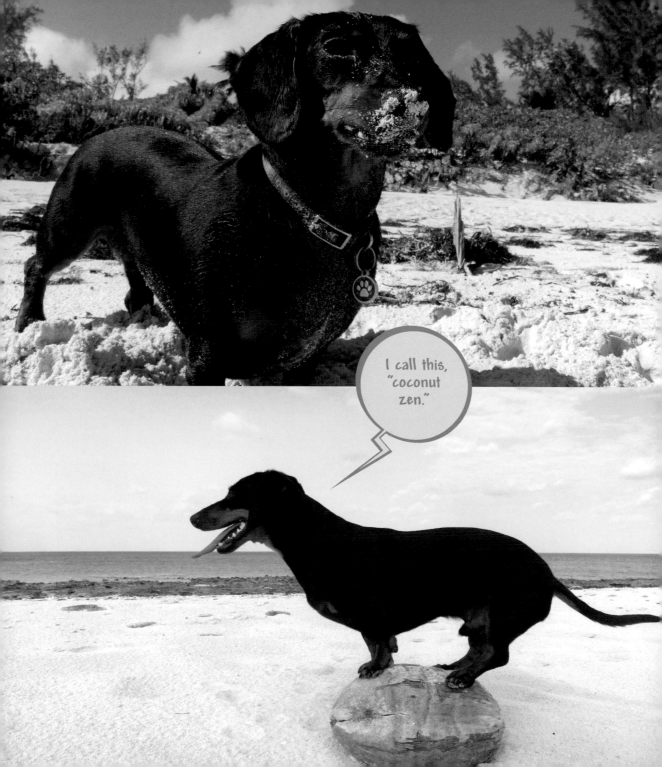

Back aboard the ship, it was time for Captain Crusoe to do some sailing himself.

So as the acting captain of the ship, I then took to my post—which Mum informed me was technically the kitchen table, but to me was my command chair.

From here I could easily bark commands to my helmsman behind me while directing our course ahead.

I am proud to say I successfully sailed the ship to our next destination, which was the utterly unique Pig Beach!

On this particular beach in the Bahamas, there is a population of feral pigs that were put here during the first Iraq War as somewhat of an insurance policy in case there was ever an embargo and Bahamians might need a backup food source.

came here to observe just how much better my island is."

That seemed to put him in his place, even if it was a white lie. I don't see any reason why I couldn't own my own island. (Note to self: Mark that down for next Christmas.)

So anyway, we told him we would pack up and leave, and so he left.

But there was no way I was leaving my first beach in Exuma without crackin' open a local Kalik beer and enjoying that view in my cool tropical shirt and straw hat. . . .

Ahh

A cold beer always tastes better on someone else's island, doesn't it?

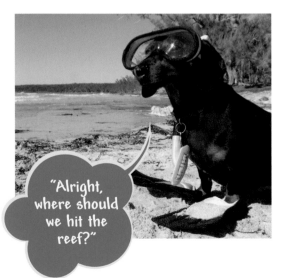

"Alright, where should we hit the reef?"

Now a tourist attraction, these pigs are quick to greet you as soon as you set foot on their shores! But let me tell you, they will be quite (vocally) disappointed if you don't bring them some fresh vegetables to eat. . . .

Luckily, they're completely vegetarian and have never tasted "hot dog" before. (Phew!)

But when one of the curly-tailed fellows got a bit too close for comfort, I wasn't afraid to tell him off.

"Hey, pig, you better back up before I show you just what 'badger dog' means. . . ."

I'm kidding, of course—I would never compromise my boyish good looks by getting in a brawl with an animal that's five times my size.

(But for the record, if push came to shove, I'd be makin' bacon.)

Yet, whether big, small, spotted, or pale and pink, it would be hard for anyone to say these little piggies aren't the cutest thing around (besides me, of course)!

After that pleasant visit with the pigs, Captain Crusoe began the trek back down south to the island of Eleuthera—a common getaway destination for the rich and famous.

We stopped at our last port for the night before making our last crossing to Eleuthera the next day.

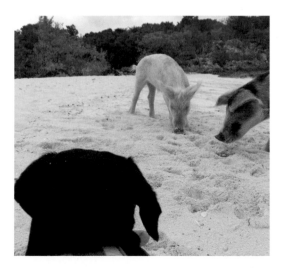

 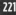

However, the next morning, after going out for breakfast and then returning to the pier, I had a little problem. . . .

"Now where the heck did I leave that ship?" (see bottom right)

I ended up finding it, but from that point, it wasn't Captain Crusoe who was to sail the ship. . . .

. . . Make way for Long Body Crusoe!

This whole time, I—Long Body Crusoe—have been waiting for the right opportunity to commandeer the ship and steer it toward my own agenda!

And now, the time was right for mutiny!

In fact, on previous days you may have noticed me practicing my pirate snarl in anticipation of this day.

I'd say I have it down pat.

You see, I have a treasure map memorized in the back of my mind that will lead me to a deserted island not far from here. I've spent many hours charting my course and drinking a lot of rum—so I'm as ready as a pirate can be!

"Hoist anchors! Full sail ahead," I yelled in my best pirate accent.

"Give me all she's got! Argh!"

After a quick trip, we made landfall. Instead of allowing my crew to have lunch, I made no hesitation in having them row me ashore.

They asked why they all had to come with me as opposed to just having one person bring me ashore, but what I didn't

tell them was that I was secretly planning to maroon them all there once I had the treasure safely in my paws.

"This looks like the place!" I called with a practiced snarl.

And once we touched ground, "Would someone please set me down on the beach, I don't want to get my paws wet. . . ."

Now it was time to do what I do best. Dig!

And boy, did I dig! I was so excited that I pretty much dug up the whole beach before I even remembered about the treasure map. All I had to do was think of the map and then I knew exactly where to dig.

And I found a buried treasure of squeaky balls! What a fantastic find!

Of course I had to test them out with a little game of fetch down the beach!

Being in such a good mood after finding my treasure, I decided not to maroon the rest of the family on the island while I made off with the prize fortune.

Plus I still really wanted to see Eleuthera, and I needed a crew to help me sail there.

So the next day we arrived at Harbour Island, famous for its pink sand beaches. And so obviously, we had to get to the beach!

But to get there we had to rent a golf cart.

As the lifelong-assigned expedition leader, I, of course, was the driver. However, I had to ask Dad to work the pedals for me, which I'll admit was a tad bit embarrassing.

My plan for the day was to just post up on the beach as the sexiest dog around and hope I might attract some Bahama mamas. After all, I'm a natural babe magnet.

Anytime now, I expect the babes will be flocking around me like seagulls around a half-eaten sandwich.

However, despite my impeccable good looks, there unfortunately weren't any attractive ladies of the canine sort to be found.

So with nothing better to do, I decided I'd have a little fun. . . .

. . . By becoming #SHARKWIENER and scaring the bejeebers out of some of the unsuspecting beachgoers.

Next time you're frolicking and having fun at the beach . . . watch your back for #SHARKWIENER—terror of the deep!

So that wraps up my Bahamas vacation! What an adventure! Tomorrow it's back to the real world—The Life of a Celebrity Dachshund—but in the meantime I'll be enjoying this last sunset with Mum.

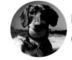 Keep diggin',
Crusoe

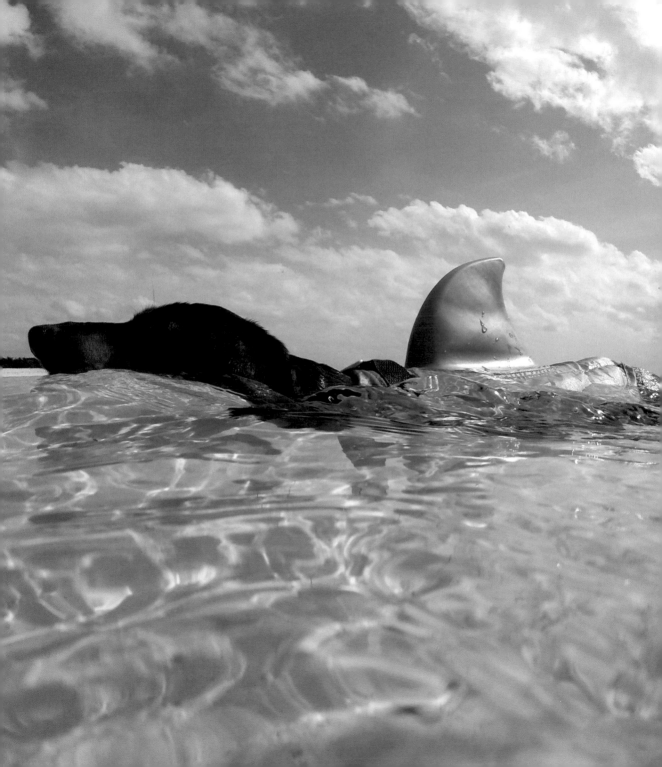

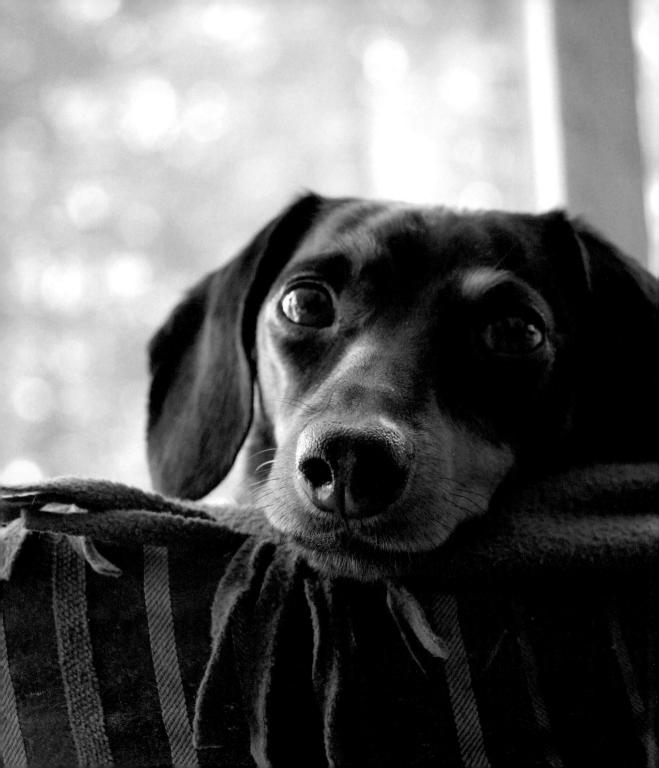

Fin

That's all, folks!

See you on the next adventure, there's always more to come. And remember . . .

 Keep ballin',
Crusoe

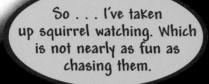

Afterword

Did you enjoy my intrepid adventures? Be sure to join my online communities to see more and stay tuned for more celebrity things coming your way!

Facebook.com/crusoedachshund

Vine.co/crusoe

Instagram.com/crusoe_dachshund

Twitter.com/celeb_dachshund

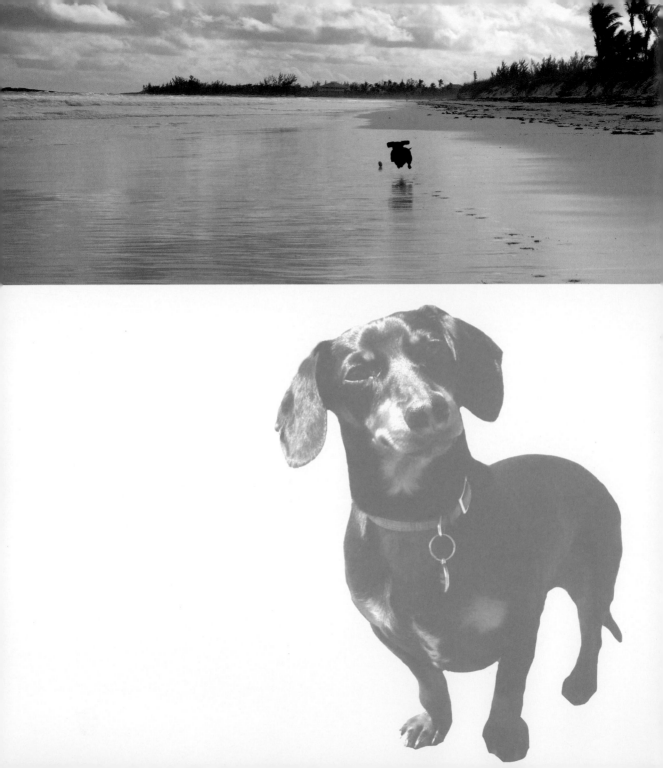

Acknowledgments

There are many people I have to thank for helping me become a celebrity and lead such amazing adventures.

The first to thank would be my best friend and mother-figure, Laffie, who's been with me since I was a pup to teach me everything I know about being a great adventurer in the outdoors.

Then I would thank my Uncle Jack and friend, Charles, the two fishermen of the family, who helped develop and facilitate my incredible obsession with fishing.

I also thank the rest of the family, including Carole, Eileen, Denis, Cameron, and Calvin, who have all, at some time or another, kept me company, assisted in setting up and conducting photo shoots, or played an embarrassing role in one of my videos.

Of course I cannot forget my very own Mum and Dad, who together don't really do much besides feed me and walk me. Okay-okay, I guess they take me on faraway trips, give me daily massages, make me cool outfits, and work tirelessly to see to my every whim. However, they still have not bought me that island in the Bahamas I really want, so I'm not quite at 100% appreciation yet.

I also want to thank my editor, Daniela,

and her whole team at St. Martin's Press who saw the potential in my book, and who helped sneak me into the Flatiron Building in New York City.

Last, I want to thank you—the fans, who are really the ones who have made this possible—for a celebrity with no fans is not a celebrity. Thanks for reading, smiling, and spreading the word to the world of the wiener dog extraordinaire—me!

Keep ballin',
Crusoe